HAND Lettering OFF THE PAGE

Easy Projects to Create Beautiful
Décor, Apparel and Gifts

Amy Latta

Author of *Hand Lettering for Relaxation*,
Hand Lettering for Laughter and *Hand Lettering for Faith*

PAGE STREET
PUBLISHING CO.

FOR BELINDA.

Teaching you to find and use the creativity you didn't think you had changed my life.
Because of you, I've spent the past eight years on a mission to help people
(especially those who feel the least confident in their abilities) learn to create beautiful things.
Thank you for the honor of helping you discover that you were created to create.

Contents

GIFTS

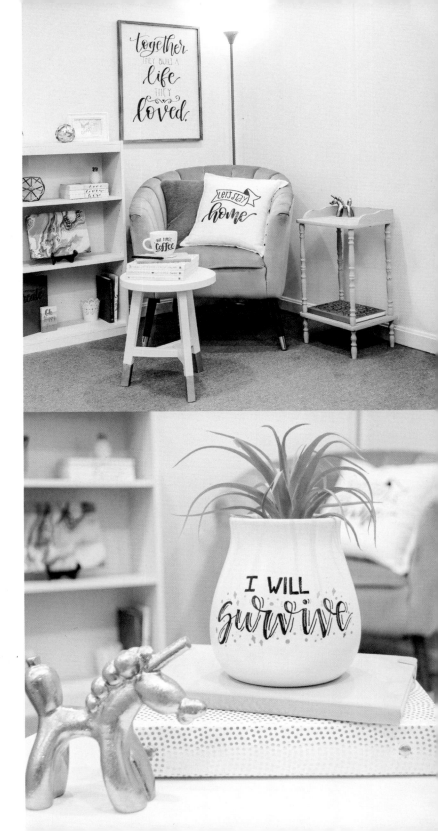

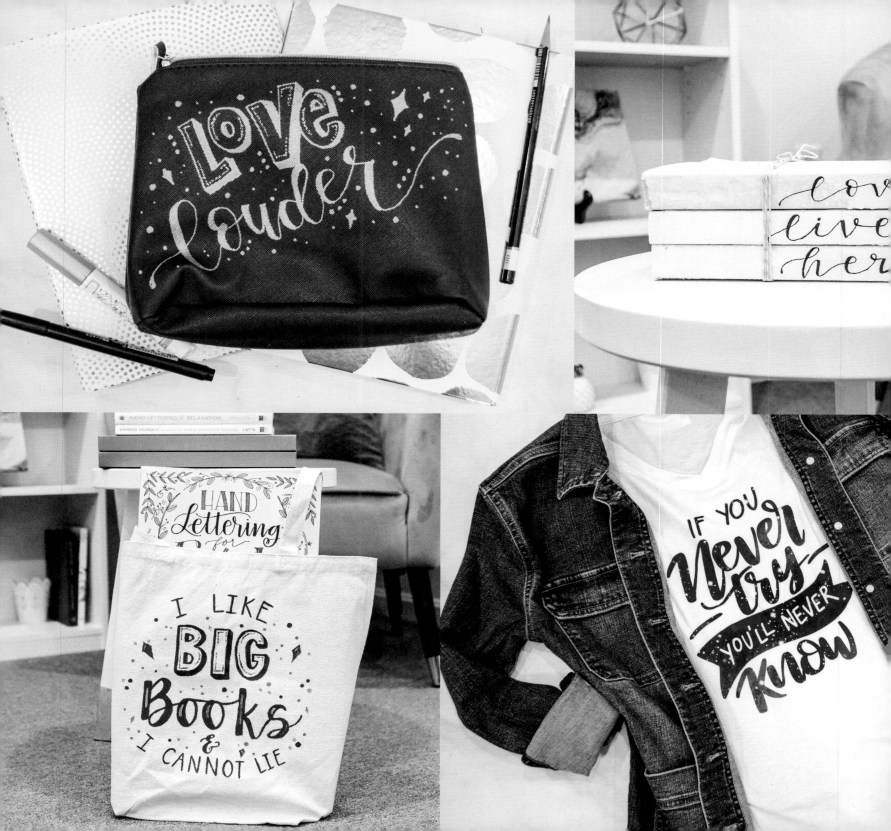

INTRODUCTION

If you're anything like me, once you start hand lettering, you won't want to stop! You'll find yourself looking around and wanting to letter everything. While the art of hand lettering is often done with pens and paper, it's fun to explore other media and see how you can bring things to life with your lettering skills. With the right materials, you can take just about any surface and personalize it with a hand lettered design.

In this book, we're going to explore 25 projects you can create, including home décor, apparel and gifts. Each chapter will show you a finished project and walk you through exactly how to recreate the design I used; but you can also take the general instructions and go your own way, creating something totally unique.

Along with techniques for adding lettering to many different kinds of surfaces, you'll also find all the hand lettering instructions you need to get started. If you're already a pro, you'll find some new skills and designs to help take your hobby to the next level. We'll begin with the basics—Faux Calligraphy—in our first project, then build on our skills, adding to them as we go. Each project tutorial teaches a different font, lettering technique or skill for lettering on a new material. Then, at the end of every tutorial, there's a blank page with practice space where you can sketch the design you want to use on your project. In the back of the book, you'll find resources like sample alphabets and detailed supply lists to help as you create. Finally, it's time to grab your supplies and take your lettering off the page, making one-of-a-kind crafts you'll love to display, wear and share.

Are you ready? Let's start creating a hand lettered life!

Amy Latta

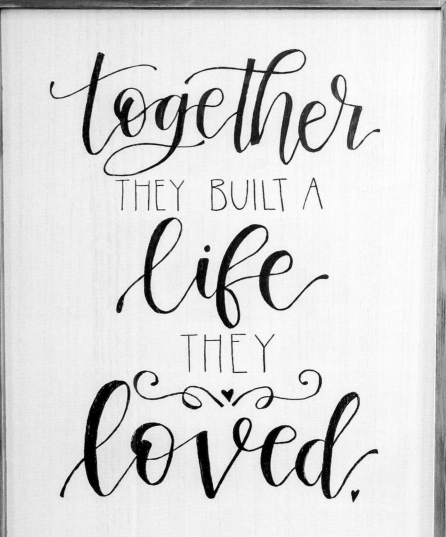

together
THEY BUILT A
life
THEY
loved.

friends
BECOME
OUR
CHOSEN
FAMILY

Home Décor

Not only is lettering a relaxing, enjoyable hobby, but you can also use it to bring a custom hand lettered look into your home! If you've shopped for home décor in the past several years, you already know that hand lettered signs, chalkboards and other forms of decoration have become incredibly popular. You can find and purchase them just about anywhere, but it's so much more fun to create your own instead. That way, you can use the exact materials you want and customize the message of each piece to reflect who you are. DIY lettering projects allow you to have complete creative control, using quotes you love or the names and dates that mean the most to you. Plus, you get to use colors and styles that match the things you already own.

The first nine projects we'll be creating together will get you started making beautiful accents for every part of your home, using techniques like Faux Calligraphy (page 12), Caps-Lock Print (page 18), Elongated Script (page 38), florals (page 31) and banners (page 44). I recommend starting with the first project if you're new to lettering, since the skills build on one another as we go. From the kitchen table to the living room couch, you'll love the way your lettering will bring a personal touch to your home décor.

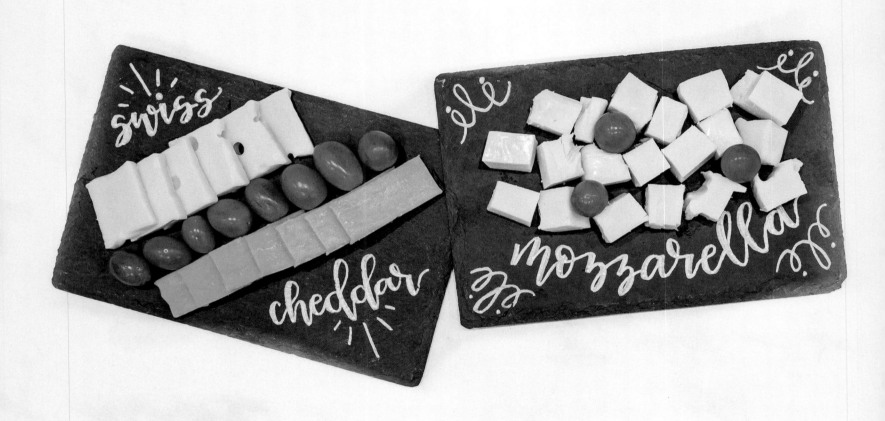

SLATE SERVING TRAY

WRITING TOOL: Chalk Marker

SURFACE: Slate Serving Tray

TECHNIQUE: Faux Calligraphy

Bringing our hand lettering into the kitchen is a great way to make the heart of the home extra warm and welcoming. In this project, we're going to look at lettering on a slate serving tray. Trays can be both functional and decorative, and there are so many ways to personalize them. For example, what better way to let guests know what you're serving than to letter the names of the foods and beverages they'll be enjoying? Using a liquid chalk marker allows us to get a smooth, professional look while keeping our written messages erasable and nontoxic. I'm going to walk you through exactly how to create Faux Calligraphy to give your writing the look of Brush Script, the most popular form of hand lettering. Then you can follow the instructions to customize your own serving trays to say anything you like!

YOU'LL NEED

- Pencil and eraser
- Chalk marker(s)
- Slate serving tray(s)
- Clean, damp cloth
- Clear glossy or matte acrylic sealer (optional)

STEP 1: **Plan your menu and practice writing the name of each food or drink in Faux Calligraphy.**

Brush Script is what we call the lettering style in which each individual letter is formed with a combination of thick and thin lines. This can be done with a tool called a brush pen, which creates different types of lines as a reaction to the amount of pressure you apply to it while writing. However, most brush pens are ideal only for writing on paper surfaces. So, when we want to letter on other types of materials, like our slate serving tray, we have to find ways to make our tools (like chalk markers, paint markers and more) create the same effect.

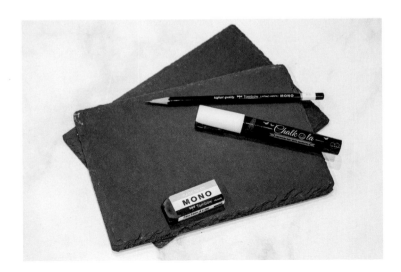

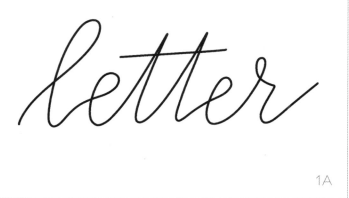

1A

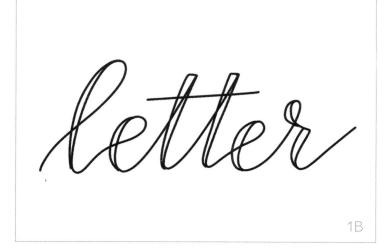

1B

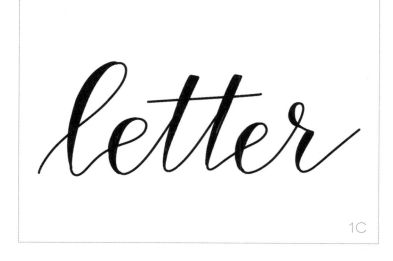

1C

The method we'll be using to do this is called Faux Calligraphy, and it's very easy to do. If you're already a pro at this skill, you can hop over to step 2. If not, here's a quick tutorial to get you started. We'll be using Faux Calligraphy for many of the projects in this book, so it's a good idea to spend some time practicing and learning it. First, we write a word in cursive (Image 1A). You may want to leave a little extra space between your letters so that you have room for the next part of the process.

The next step is to locate the downstrokes in each letter. Every time we write, our pen moves across the paper in one of three basic ways: up, across or down. When our pen is moving up and away from us, that is an upstroke. When it goes across the paper, that is a horizontal stroke. And when it moves down toward us, that is a downstroke. Downstrokes are the parts of the letter that are made of thick lines; upstrokes and horizontal strokes remain thin. Once you understand this concept, you know the big secret behind beautiful Brush Script lettering (which we'll dive into more on page 148). For our Faux Calligraphy, when we find the downstrokes in each of our letters, we need to do something to thicken them. So, we're going to draw a second line next to our original downstroke (Image 1B). To help you locate the downstrokes in each letter of the alphabet, check out the reference guide for the full Faux Calligraphy alphabet on page 157. That way you'll know you're thickening the correct parts of your words.

All that's left to do is color in the space between our double lines. This artificially thickens the line, making a contrast between the downstrokes and the rest of the letter (Image 1C).

See? This technique isn't hard at all, and it creates beautiful results every time. It can be done with literally any type of pen, pencil or marker, so no matter what you're lettering on or with, this is a skill you'll be able to use. The last page of this tutorial has plenty of space for you to practice Faux Calligraphy as much as you'd like with a pencil and eraser before beginning to letter on your tray.

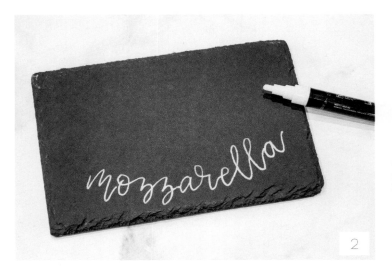

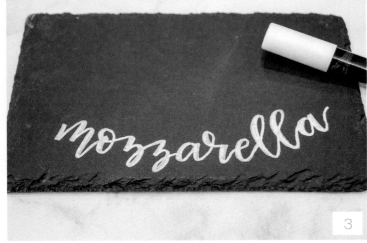

STEP 2: **Use a chalk marker to write your words on the tray in cursive.**

While the chalk marker is nontoxic, we don't want it physically touching food, so be sure to keep your writing close to the edges or corners of the tray. Another option is to write in the center of the tray and arrange the food around it.

PRO TIP: Test your marker on the back of your tray first to make sure it really does erase well from the slate surface. Most chalk markers will come off when wiped with a clean, damp cloth, but it's good to check before you start!

STEP 3: **Add double lines to each downstroke and fill them in with chalk marker.**

Just like we practiced, we're going to create those thick lines to give us a beautiful Brush Script effect.

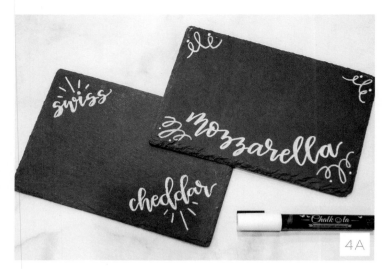

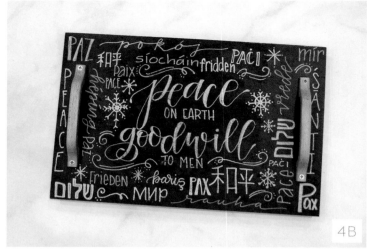

STEP 4: **Add lines, arrows or swirls to embellish.**

You can certainly leave your tray as is, but I like to add decorative elements too. Drawing an arrow from your label word to the food itself is one simple way to do this. I also like drawing three or five short lines coming out from the word like a sunburst, and I enjoy making little swirls in the corners (Image 4A). There's no wrong way to do this—just have fun and see what you can create! Remember, chalk marker is erasable, so if you don't like something you draw, you can erase and try again.

Once your writing and embellishing is complete, all that's left to do is add your food or drink and serve it to your guests.

Of course, you can write other types of messages on your tray as well, like wishing someone a happy birthday, congratulating a couple on their anniversary or offering best wishes for a new job venture. Other possibilities include writing out a recipe on the tray or lettering seasonal messages, like this holiday tray I created using the word for "peace" in as many different languages as possible (Image 4B). If you plan to decorate the tray's entire surface, you'll want to place food in bowls or on plates before serving it on the tray.

Typically, I like erasing my designs and creating new ones for different seasons and occasions. However, if you want to make your work permanent, you can do so by covering your tray with a clear glossy or matte acrylic sealer. No matter what designs you create or how often you change them, these trays are sure to add a personal touch to your kitchen!

VINTAGE BOOK STACK

WRITING TOOL: Fine-Tip Marker

SURFACE: Books

TECHNIQUES: Faux Calligraphy (page 12),
Caps-Lock Print

Decorative books are some of my favorite things to display on end tables, bookshelves and more. Here's a simple and very inexpensive way to customize your own stack of books while incorporating your hand lettered art. Since we will be lettering on a paper surface for this project, we can use our favorite "regular" markers for the job. I chose to use a fine-tip black marker with a size 05 tip. The best part about this project is how personal you can make it. Not only can it be a unique piece of décor for your home, but it also makes a thoughtful gift for a wedding, baby shower, retirement, birthday or other celebration. Here are a few ideas: "choose joy," "Mr. & Mrs.," "family is forever," "we are blessed," "Joe & Mary, Joshua, Hannah," "Latta family, Dan & Amy, est. 2001."

YOU'LL NEED

- Paperback books (I chose three that were similar in size, but you could also go from large to small)
- Pencil and eraser
- Fine-tip black marker
- Ruler
- Twine, string or ribbon
- Scissors

STEP 1: **Carefully peel the cover from each book.**

This may seem intimidating, but it's actually easy to do. Just grab the front cover and start gently pulling toward the spine. Once the covers are removed from all of your books, choose how you want to stack them. I wanted a blank page on top, so I actually flipped one of the books upside down because it had a blank page at the end.

PRO TIP: Thrift stores and yard sales are great places to get inexpensive books of all shapes and sizes!

love
lives
here

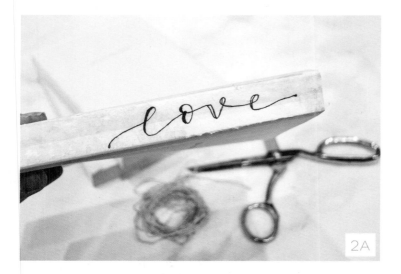

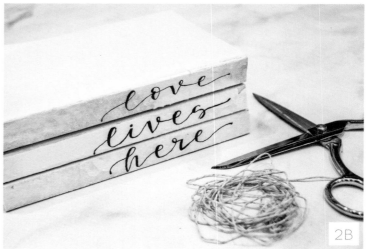

STEP 2: **Letter your phrase onto the spines of the books.**

I chose the phrase "love lives here" and wrote one word on each book. You can do the same, or you can use any phrase or combination of words, names and dates you like. The words can be aligned on the left of the book spines or on the right. I don't recommend centering them, because when you tie them together, the string will cover anything in the center and make it difficult to read.

To do the lettering, we will be using the Faux Calligraphy technique (page 12), so we'll start by writing our words in cursive. Then we'll go back and find the downstrokes of each letter and draw a second line next to each downstroke. Color in the space between the double lines to make the downstrokes appear thicker than the rest of the strokes in each letter (Image 2A). You can use the blank page on page 20 to practice your lettering before trying it on the books. Once you're ready, I recommend lightly writing the words in pencil first on the spines to make sure that you're happy with the positioning then tracing over them with marker. When the marker is dry, you can erase any remaining pencil lines (Image 2B).

STEP 3: **Personalize the top of the stack with lettering.**

You can create any type of design here that you like. I recommend keeping it simple, though, so it doesn't distract too much from the words on the spines. Rather than using Faux Calligraphy, I chose to use what I like to call Caps-Lock Print. This font is simple to create, simply by moving the x-height in your printed letters. Here's what I mean: When we write, there are guidelines that we use to position our letters. There's a baseline, which is where the bottoms of our letters sit. The cap height is the line where the tops of our capital letters reach. Then, usually located in the center of those two, is what we call the x-height. When you first learned to write, the x-height was probably represented on your paper by a dashed line between two solid ones. The x-height is where we do things like cross an "H" or an "A," as well as where we put the center of our "B" or finish the loop on a "P."

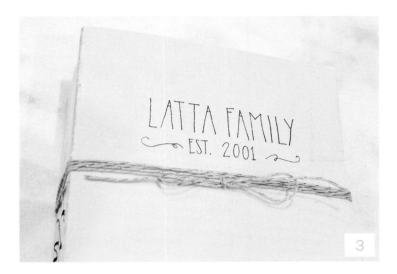

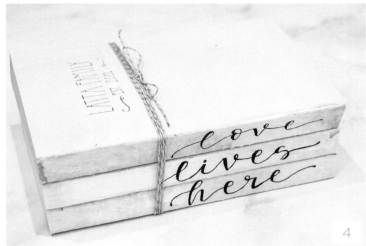

By choosing to move that x-height line, we can completely change the way our letters look. See what happens when we bring that line up, making it much closer to the cap height? Now our letters have a stylized appearance, more like art and less like our regular printed handwriting. To see the full alphabet written in this font, check out the Alphabet Reference Guide on page 158.

I used this style of writing to letter "Latta family, est. 2001" on the blank page on the top of my book stack. It's a good idea to use a ruler and a pencil to draw two very light guidelines so that your lettering is straight. Mark where the center is, then lightly pencil in your words, starting with the center letters of each line and working your way out. Then trace over your words with your fine-tip marker and erase any remaining pencil lines. Remember you can practice the new font style on page 20 first if you'd like!

STEP 4: **Tie your books together with twine, string or ribbon.**

I like the neutral, natural look of twine, but if you prefer to use ribbon that matches your other home décor, go for it! Trim the twine, string or ribbon with scissors and tie it to secure the book stack.

That's all there is to it. Once your books are tied together, they are ready to go on display. Once you try this project and see how simple, quick and inexpensive it is, you'll want to make a stack for every room in the house and everyone on your gift list!

INSPIRATIONAL MIRROR ART

WRITING TOOL: Paint Marker

SURFACE: Mirror

TECHNIQUES: Faux Calligraphy (page 12), Caps-Lock Print (page 18), Bounce Lettering

Almost every room in my home has at least one mirror on the wall. It's not because I want to know if I need to fix my hair (although that can be an added benefit); it's because mirrors have a way of brightening up a space and making a room feel larger than it actually is. Adding a hand lettered message to a mirror can make it an even prettier piece of statement décor. Some people also choose to use lettered mirrors as seating charts or other displays for formal events. Although they're a bit tricky to photograph, they're uniquely beautiful and add a personal, elegant touch to your home or occasion. While you can certainly purchase a new mirror for this project, you can often find a great deal on a gently used one at a thrift store or yard sale. Mine was just $4.99!

YOU'LL NEED

- Pencil and eraser
- Mirror of any size and shape
- Rubbing alcohol or glass cleaner
- Soft, lint-free cloth
- Ceramic marker or dry-erase marker
- Meter stick or measuring tape
- Oil-based paint marker
- Damp cloth

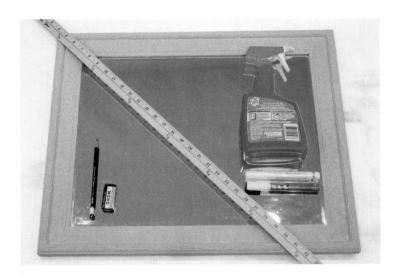

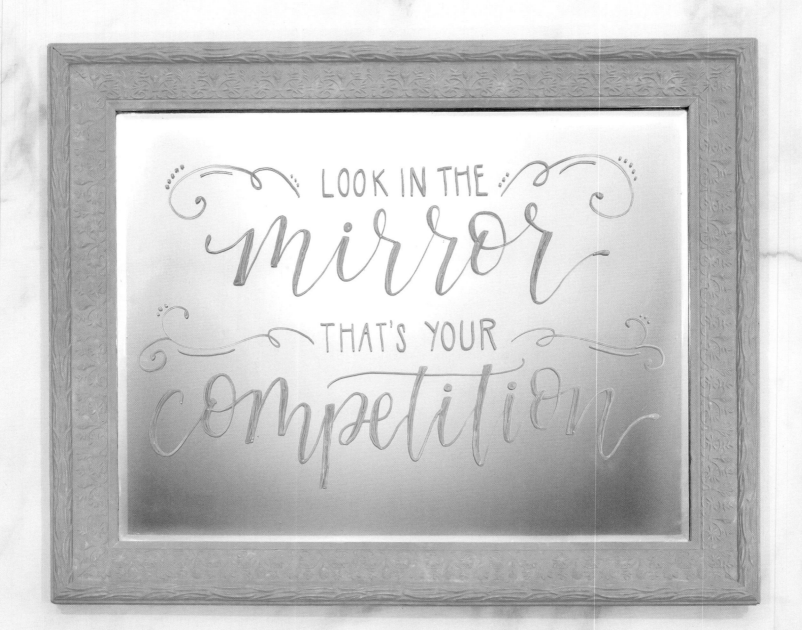

1A

1B

STEP 1: **Plan your design.**

First, sketch your layout using a pencil and the practice sheet on page 26. You'll want to draw some guidelines to help you recognize where the center of the page is and how the various parts of the design are spaced. I like to start by drawing lines that divide the paper in half vertically and horizontally, and then I sketch the shape I want my design to take. Keep in mind the dimensions of your mirror as you sketch.

The phrase I chose to letter on my project is a reminder to step out of the comparison game and stop measuring myself against other people. It says, "Look in the mirror; that's your competition." My goal is to be a better version of me than I was yesterday and to gauge my success based on how far I've come, not on what someone else is doing. Design-wise, I wanted to emphasize the words "mirror" and "competition," so I wrote those larger than the rest of the phrase using Faux Calligraphy (page 12). As I wrote, I applied a technique called bounce lettering to really make them pop. This can be done in any font; it simply means that rather than keeping our letters lined up nice and straight, we allow some of them to drift higher or lower than others (Image 1A).

While there are no hard-and-fast rules for exactly where to place each letter, here are a few tips to help you as you practice. First, I've found that for letters that end with a downstroke, like "h," "l," "m," "n," "r" and "t," it feels and looks natural to extend that downstroke a little lower than you normally would before heading back up to form the next letter. These will become the lower points in your word. Letters like "m" and "w," which would normally have multiple lines at the same height, look more interesting if you let one half of the letter be higher than the other.

Finally, pay attention to the word as a whole. Try to balance it out, making sure there's a good mixture of higher letters, lower letters and letters in the middle. Sometimes the best way to decide how to place a letter is by looking at the one next to it. It's all about trial and error, playing around until you get a look you like. That's why I like to practice my words in pencil first, getting a feel for how I want them to look on my finished project. In Image 1B, I've shared a few example words and how I would apply bounce lettering to them.

Letter the rest of the phrase in Caps-Lock Print (page 18), then add a few swirls for embellishment (Image 1C). At the end of this tutorial, there's a blank page that's perfect for creating a draft like this one. If you'd rather letter a different sentiment on your mirror, go for it! Use any combination of fonts and embellishments you like to create something truly unique.

STEP 2: **Clean and dry the mirror. Use a meter stick and ceramic marker to make guide marks.**

Even the smallest bit of dust or a fingerprint can interfere with your lettering, so you'll want to thoroughly wipe the surface of the mirror with rubbing alcohol or glass cleaner and dry it with a soft, lint-free cloth.

Part of why I like using bounce lettering for a project like this is that I don't have to worry about keeping all of my letters perfectly aligned. However, we do want the Caps-Lock Print letters to be straight, so for each baseline, make sure there's a small mark on either side of the mirror to indicate where it goes. I also like to mark the center of the mirror. Make sure to use a ceramic marker and not your paint marker for this step, so that you can easily erase it when your project is complete.

PRO TIP: The trickiest things about writing on a mirror are the fact that you can see the reflection of your own letters as you write and that whatever is around you will be reflected as well, potentially acting as a distraction. I like to put my mirror on the floor of a room that has a plain white ceiling to help minimize the reflections as I work.

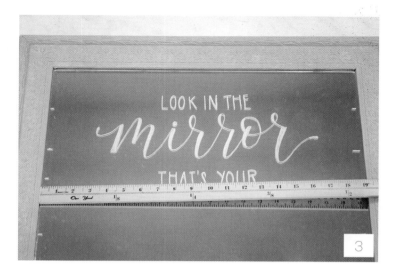

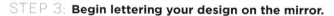

STEP 3: **Begin lettering your design on the mirror.**

Switch to your paint marker and start lettering! To help keep your printed letters straight, line up your meter stick or measuring tape with the marks on each side of the mirror. Leave your measuring tool there to act as a baseline, showing you where to write. If you have a letter with a descender, like a "p" or a "g," gently slide the measuring tool out of the way as you write that part, then return it to its position. As you work your way through the design, continue moving this baseline until you finish lettering.

PRO TIP: I like to work from top to bottom of the design to avoid getting my hand in wet paint and smearing my work.

STEP 4: **Erase your guide marks.**

A damp cloth will do the trick to make your marks disappear.

If you want your design to be a permanent part of the mirror, you'll be pleased to know that the paint marker will withstand water and look as good as new for as long as you want it to. However, if you change your mind and want to create a new design, it can be removed with rubbing alcohol. You may also want to gently scrape the paint with a single-edge razor to speed up the removal process. Mirror art like this is a beautiful addition to any room in the home, and it can also be used to add a touch of elegance to weddings or other celebrations. This same technique can be applied to lettering on windows too, such as the front window of a shop or restaurant.

WOODEN WALL SIGN

WRITING TOOL: Acrylic Paint Marker

SURFACE: Wood

TECHNIQUES: Faux Calligraphy (page 12), Caps-Lock Print (page 18), Bounce Lettering (page 23)

One of the most common places you'll see Brush Script (page 148) and other hand lettering is on decorative wall signs. A trip to HomeGoods or Hobby Lobby will confirm that signs with lettered phrases are totally on trend. Rather than buying them, why not create your own masterpieces to deck the walls? You'll save money, plus you can personalize them with exactly the words you want in the perfect sizes for any room in your home. Be forewarned, though, that after you make one, you won't want to stop! Since this sign is for your home, it's the perfect opportunity to letter something meaningful to you. I chose the phrase "Together they built a life they loved," because that's exactly how I feel about our family. Feel free to make your sign with the same quote or to choose something else that reflects your story.

YOU'LL NEED

- Pencil and eraser

- Meter stick

- Wooden wall sign (mine was a whitewashed framed one from Hobby Lobby)

- Acrylic paint marker (I used black)

STEP 1: **Draw a plan.**

First, use a pencil and the blank page on page 30 to practice the lettering. In the example quote, we will emphasize the words "together," "life" and "love." Write them in large Faux Calligraphy script (page 12), placing each one on its own line. Then, fill in the words, "they built a," and "they," in Caps-Lock Print (page 18). Make sure to locate where the center of each line would be so that you can position the words properly. For the words in Faux Calligraphy, try using the bounce lettering technique we learned on page 23. Stylistically, the bounce looks great, and it also takes away the pressure of trying to get your letters completely straight.

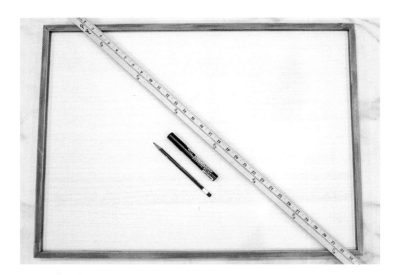

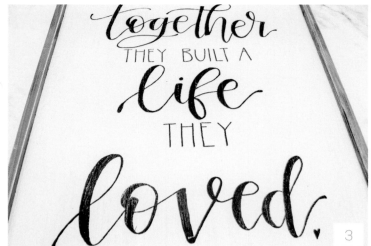

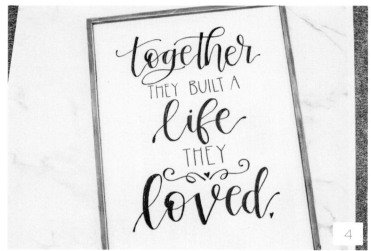

STEP 2: **Lightly sketch guidelines and word positions on your surface.**

Use a pencil and a meter stick to draw five horizontal guidelines (or however many your own design requires). Measure and mark the center of the sign, drawing a vertical line you can use to align your words. Then lightly draw the positions of your letters. I like to start in the center of each line and work my way out to the sides. To make the design more interesting, you can add a simple swirl embellishment between the words "they" and "loved." All you have to do is sketch a shape similar to the number "2" with a long curling tail on the right side, then mirror it on the left. A tiny heart in the center is the perfect way to complete the embellishment.

STEP 3: **Letter your design using a paint marker.**

I chose to use a black marker, in keeping with the farmhouse style. However, you can certainly use other colors instead. Trace your sketched letters, then go back and thicken the downstrokes in your Faux Calligraphy. I suggest working from top to bottom so that you don't get your hand in any wet paint.

STEP 4: **Erase any remaining pencil lines.**

Wait for your lettering to dry completely, then go back and erase any pencil marks you can still see.

That's all there is to it! Now you have a beautiful piece of personalized wall art that's ready to display anywhere in your home. While I'm sure you'll want to keep it for yourself, a piece like this can also make a wonderful gift. Wooden sign surfaces are available in a huge variety of shapes and sizes, so there are many variations of this project that you can create for all the different rooms in your house.

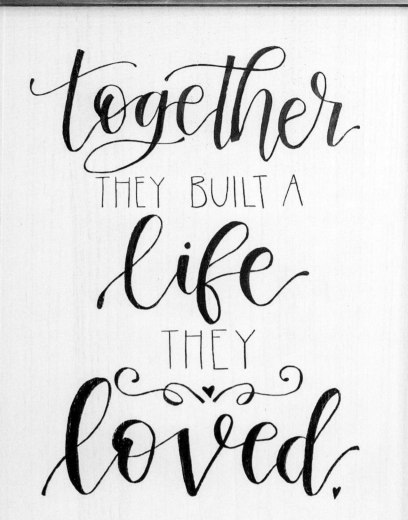

together
THEY BUILT A
life
THEY
loved.

friends
BECOME
OUR
CHOSEN
FAMILY

FAMILY NAME FLORAL CANVAS

WRITING TOOLS: Paint Markers

SURFACE: Stretched Canvas

TECHNIQUES: Faux Calligraphy (page 12), Caps-Lock Print (page 18), Florals

In the previous project, we learned how to create a wooden sign to decorate the large open spaces on our walls. Sometimes, though, we need wall décor on a smaller scale. In addition to using wooden surfaces to create signs, we can also turn to a tried-and-true medium artists have used for centuries: canvas! While you can use canvas as a base for watercolors, oil painting and other fine art, it's also a great backdrop for a hand lettered design. We're going to look at how easy it is to customize an 11 x 14–inch (28 x 35.5–cm) canvas using your lettering and some basic floral illustrations to make a meaningful addition to your home. Our sample project incorporates your last name along with a significant date inside a floral wreath. Of course, as always, you can change the design to express anything that's important to you.

YOU'LL NEED

- Blank stretched canvas in the size of your choice
- Pencil and eraser
- Acrylic paint markers

STEP 1: **Sketch a rough draft of your design, then lightly pencil it onto your canvas.**

Making a quick pencil sketch on the last page of the project instructions (page 35) will give you an idea of how you want to space your words within the wreath shape. Don't worry about being too detailed with the actual lettering or illustrations in your draft; it's just a quick plan to get your ideas out.

PRO TIP: If you'd like something other than a white background, give your canvas a full base coat of paint or watercolors before you begin the project.

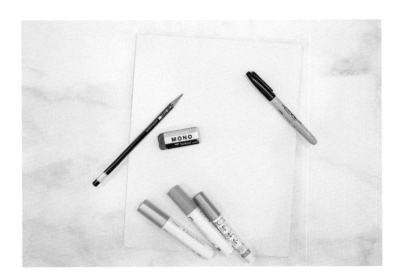

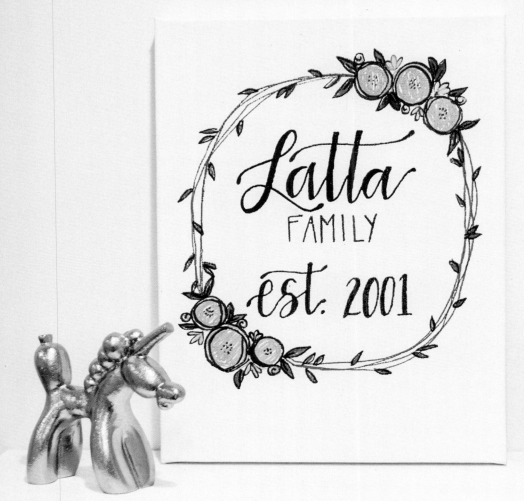

Latta
FAMILY

est. 2001

love
lives
here

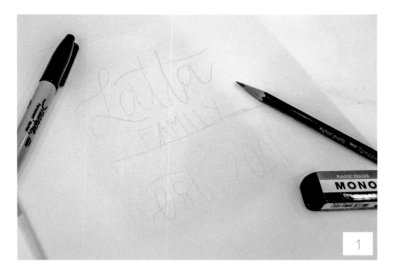

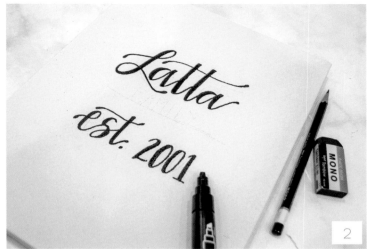

First, use a pencil to very lightly sketch horizontal lines where your words will be on the canvas. Be careful not to draw too heavily since these guidelines will need to be erased later.

Draw your last name in large letters using Faux Calligraphy (page 12) and use the same font for "est." Add "family" and the year you got married (or another significant year) in Caps-Lock Print (page 18). Feel free to adapt the design with your own favorite combination of fonts, if you like.

Now let's create the floral wreath. It may look fancy, but it's actually very easy to draw! First, make several overlapping circles or ovals to provide the basic wreath shape. Next, choose where you want your flowers. For each main flower, draw several smaller overlapping circles and place a series of dots in the center.

Draw tiny spirals next to these flowers to look like rosebuds and little teardrop shapes to form daisy petals. To finish off the wreath, add leaf shapes all around it, some on the inside and some on the outside. Feel free to practice the flowers and leaves on your planning page to get comfortable with them. In the back section of the book on page 166, you'll find more step-by-step drawings of these florals to help you learn. There's no wrong way to draw or position these florals around your wreath, so give yourself some creative freedom and see what happens!

PRO TIP: It's always a good idea to test your pencil and eraser in a small, unnoticeable area first—such as the back or side of the canvas—to make sure the pencil lines erase cleanly on that particular canvas.

STEP 2: **Trace over your design with paint markers.**

There are many different types, sizes and colors of paint markers to choose from. I personally prefer fine- to medium-sized bullet-tip acrylic paint markers for canvas signs smaller than 16 x 20 inches (40.6 x 50.8 cm), because they are easy to control and make it possible to do small detail work. You can use your favorite colors or shades that match your existing home décor. If your paint markers have never been used before, you'll need to shake them then press the tip firmly onto a piece of scrap paper to get the ink flow started. It may take a few minutes for the ink to reach the tip. Once the tip has fully turned the color of the paint, the marker is ready to use.

PRO TIP: After being applied, the paint from a paint marker stays wet for a few minutes, so be careful not to put your hand in other parts of the design while you're working.

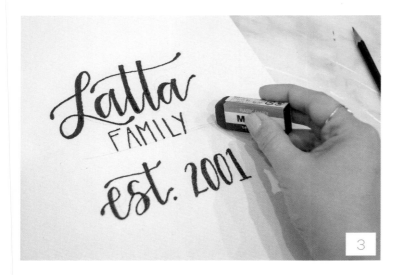

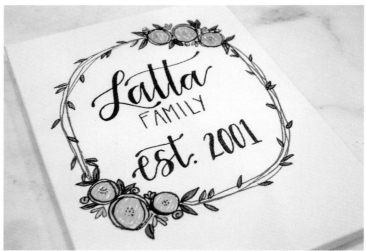

STEP 3: **Erase your pencil lines.**

Make sure all of your work is completely dry before you attempt to erase anything. I like to wait at least an hour to make sure I don't create any unwanted smears.

Once your guidelines are erased, your project is ready for display! You can hang your canvas directly on the wall, or if you want to add an extra finishing touch, you can purchase a floater frame, which is a deep frame without a glass front that's perfect for showing off your art. These hand lettered canvases not only make personal pieces of home décor, but they're also a great gift idea for a bridal or baby shower, a holiday or a birthday. Just think of all the possibilities!

STRIPES AND VINES FRONT DOOR SIGN

WRITING TOOLS: Paint Markers

SURFACE: Painted Wood

TECHNIQUES: Faux Calligraphy (page 12), Elongated Script

A guest's first impression of your home starts at the front door. Why not make it a great one by using your lettering to create a welcoming door sign? Door décor comes in all shapes, sizes and materials, but today we're going to focus on using a sign made from natural unfinished wood. You can find a variety of unfinished wood surfaces like this one at your local craft store or even in the craft aisle of large retailers. I'll be walking you through how I painted and lettered the sample design so that you can create your own version. Feel free to use the same colors and techniques I did or to personalize your sign using colors and styles that coordinate with your home.

YOU'LL NEED

- Large paintbrush
- Acrylic or chalk paint (white and gray)
- Unfinished round wooden sign
- Painter's tape (1.88" [48 mm])
- Ruler
- Pencil and eraser
- Fine- or medium-tip paint markers in your choice of colors (I used black, white, blue and gold)
- Twine, scissors and hot glue (if your sign doesn't come with a pre-attached hanger)

STEP 1: **Paint the wooden sign white, then apply strips of painter's tape to create stripes.**

Use the large paintbrush to apply an even coat of white paint to the entire surface of the sign, including the edges. Let it dry completely, then if necessary, apply a second coat for total coverage.

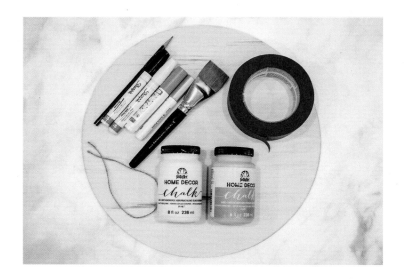

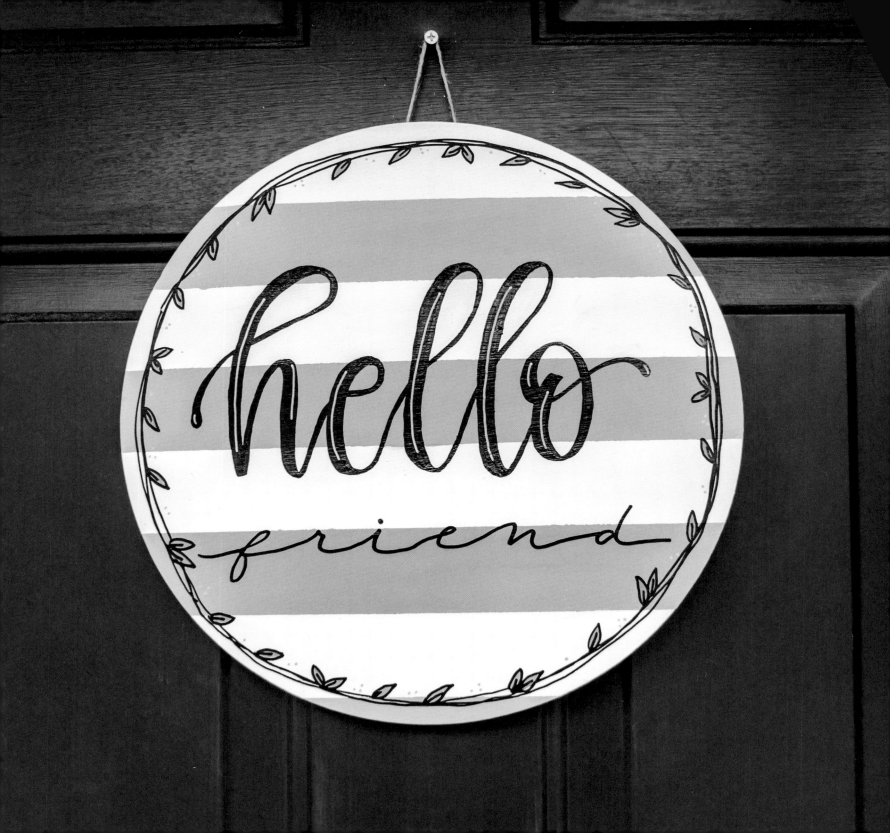

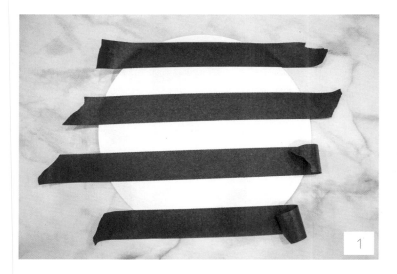

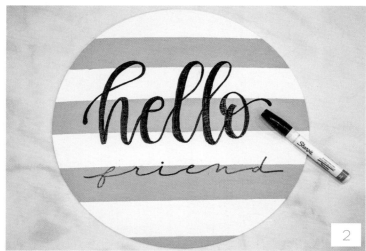

It's time to apply your painter's tape. Any area covered by the tape will remain white while you paint with gray everywhere else. First, place a strip of tape across the very top of the sign. Then use a ruler to measure down from the bottom of the tape to where your next stripe will go. For example, since I used 1.88-inch (48-mm) tape, I measured and spaced the strips 1.88 inches (48 mm) apart so the stripes would be even. Make sure the base coats are completely dry before you do this step, or the paint will peel off when you remove your tape.

STEP 2: **Paint the non-taped areas gray, then add your lettering.**

Use your paintbrush to apply a coat of gray paint over the white base coat. Once you're finished, remove the tape while the paint is still wet. Let the paint dry completely before moving on.

Once the paint is completely dry, it's time to letter the words "hello, friend" in the center of the sign. First, use a pencil to lightly sketch "hello" in large script letters. Then, trace the pencil lines with a fine-tip paint marker and use

the Faux Calligraphy technique (page 12) to thicken the downstrokes in each letter. This will give the word the appearance of being written in brush-style lettering, even though we aren't working with a brush pen. Of course, you can substitute any lettering font you prefer, like Caps-Lock Print (page 18).

Pencil in the word "friend" below "hello" using Elongated Script. Elongated Script is a pretty, elegant style of writing made up of small script letters that have been stretched horizontally with lots of space in between. This font looks great underneath a word, as shown in our sample project, or it can also be written on top of a word that's in another font. I find that the finer the tip on my pen, the more I like the look of this font. The full alphabet written in this style can be found on page 160. Feel free to use the practice space provided on page 40 to play around with writing and combining these letters on paper before lettering on your sign. As always, I suggest using a pencil to lightly sketch the word on your sign first, then tracing over it with a fine-tip paint marker. Once the marker is completely dry, you can erase any pencil marks that are still visible.

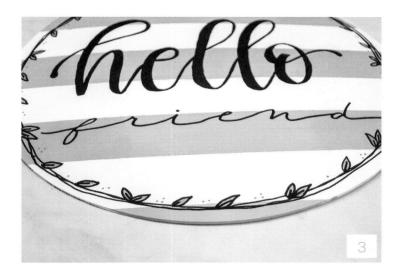

3

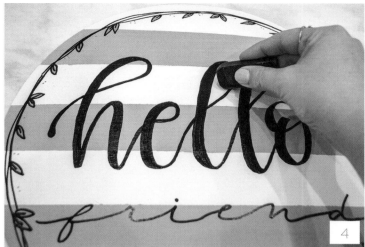

4

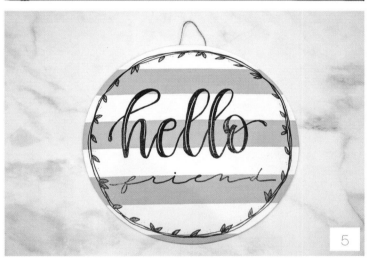

5

STEP 3: **Draw a border around the sign.**

As always, you'll want to begin by sketching this lightly in pencil. I started my border with a basic overlapping circle. To do this, just freehand a circular shape close to the edge of the sign, allowing each layer to overlap the previous one a bit. My favorite thing about this technique is that it's meant to look hand-drawn, so you don't have to worry about tracing a perfect circle. Next, add some leaves to the inside of the circles. Trace the border with a black paint marker, then color your leaves with a blue paint marker (or any color you like) and outline them in black. Finally, draw a few little gold dots between the leaves to finish creating a colorful border.

STEP 4: **Erase your pencil marks.**

Make sure all of your paint is dry, then erase any of your pencil marks that are still visible.

STEP 5: **Add highlight lines to the word "hello."**

This will make it look like light is shining on your word. To do this, use a white paint marker to draw short accent lines on top of each thickened downstroke. These lines should be narrower than the downstroke and should follow its shape.

My sign did not come with a hanger, so I needed to add a piece of twine by attaching it to the back of the sign with hot glue. If yours already has string or a nail hole, you can skip this step. Once your paint is completely dry, your sign is ready to display.

To create seasonal signs, you can follow the same instructions—just change the message to say something like "hello fall" or "Merry Christmas" and use festive colors. Adding a coordinating bow or a few faux flowers is another way to make your sign really pop. Just be ready for your neighbors to ask you if you'll make signs for their doors too!

SUBWAY-STYLE CHALKBOARD ART

WRITING TOOLS: Chalk Markers and Chalk

SURFACE: Chalkboard or Chalkboard-Painted Surface

TECHNIQUES: Faux Calligraphy (page 12), Caps-Lock Print (page 18), Bounce Lettering (page 23), Faux Calligraphy Print, Banners

Ever since chalkboards were replaced by whiteboards and screens in school classrooms, they've become popular pieces of home décor. Lettering on a chalkboard not only takes us back to the "good old days," but it also allows us the option of creating art that's meant to be changed and recreated whenever inspiration strikes. As you follow the steps in this tutorial to get started, keep in mind that you can alter the design however you like and change it at any time to reflect the season, your personality or even your current mood. Since coffee is a huge part of my everyday life, our sample project is a fun coffee-inspired piece of subway-style art. This allows us to play around with lots of different lettering fonts and styles, all within one project.

YOU'LL NEED

- Standard chalkboard surface of any size and shape (mine is 23" x 35" [58.4 x 88.9 cm]) or a smooth wooden, metal or glass surface of any size and shape, plus a wide paintbrush and chalkboard paint

- Chalk

- Soft, dry cloth

- Pencil and eraser

- Ruler or meter stick

- Chalk markers

- Damp cloth or paper towel

- Hairspray or clear matte sealer (optional)

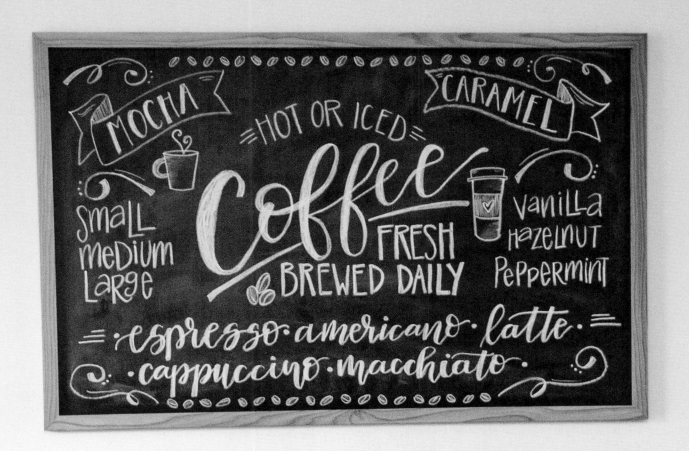

MOCHA

CARAMEL

HOT OR ICED

Coffee

SMALL
MEDIUM
LARGE

FRESH
BREWED DAILY

vanilla
hazelnut
peppermint

espresso · americano · latte ·
cappuccino · macchiato

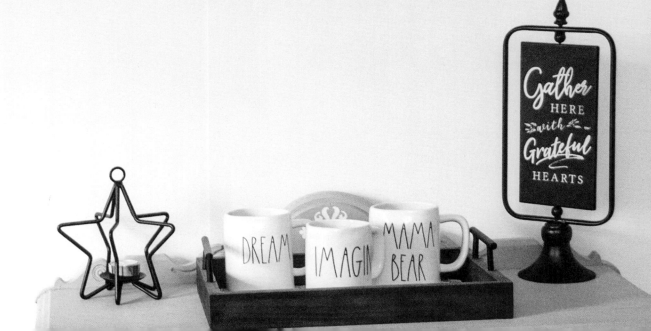

DREAM

IMAGINE

MAMA BEAR

Gather HERE with Grateful HEARTS

STEP 1: **Create a chalkboard surface (if necessary).**

If you already have an actual chalkboard, you're ready to jump ahead to step 2. If you don't, you'll need to start by creating one from a smooth, sanded piece of unfinished wood. (You can also use chalkboard paint on metal, walls, plastic and other surfaces.) Use a wide paintbrush to apply chalkboard paint to the wood. Start by painting a thin, even base coat going in the direction of the wood grain. Allow the first coat to dry for at least one hour, then apply a second coat going in the other direction (if you painted up and down the first time, this time you'll go from left to right). Two coats should be ideal, but if you want more coverage, you can apply a third coat. Allow the paint to cure completely, per the manufacturer's instructions, before moving on to the seasoning process.

PRO TIP: Chalkboard paint and chalk paint are not the same thing. Chalk paint is a specially formulated type of decorative paint designed to give furniture pieces a flat matte finish that's easy to distress and age. Chalkboard paint is a specialty paint designed to transform wood or walls into erasable writing surfaces.

STEP 2: **Season your chalkboard.**

In order for your chalkboard to erase properly, you'll need to season it before the first use. Otherwise, your markings will leave "ghosts," and you'll never be able to erase them completely. The process for seasoning is the same whether you purchased a chalkboard or painted your own. Simply rub the long side of a piece of white chalk all over the surface of the chalkboard with an up-and-down motion. Then, go back and do the same thing using a side-to-side motion. Wipe away the chalk dust with a soft, dry cloth. You'll notice that the chalkboard remains slightly cloudy, which is what you want. A jet-black color means that it hasn't been properly prepared.

STEP 3: **Plan and lightly sketch your design.**

As with any other project, I like to do a rough draft of my design with a pencil and paper before I start on my chalkboard. This allows me to plan my spacing and get an idea of how the project will look. Use the practice space on page 46 to create a draft of your lettering. Once you've created a draft, you can sketch it very lightly onto the chalkboard with a piece of chalk. For any lines of text that you want to be straight, you'll want to measure and draw light guidelines using a ruler or meter stick. (This is very similar to the preparation we did for the Inspirational Mirror Art on page 21.)

This design is an example of subway-style art; it features lots of words and phrases related to coffee written in a variety of fonts and accented with some basic embellishments. You can follow along to create the same design I did, or make it your own with different fonts and arrangements!

First, write the word "coffee" on a diagonal in the center using Faux Calligraphy (page 12), then underline it. Next, add the words "hot or iced" in Caps-Lock Print (page 18) in the shape of an arch. Below the word "coffee," write "fresh brewed daily," also in Caps-Lock Print. Across the bottom of the board, switch back to Faux Calligraphy to write some different types of coffee drinks, like espresso, Americano, latte, cappuccino and macchiato (see Image 3A on the next page).

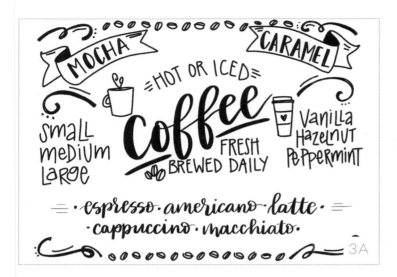

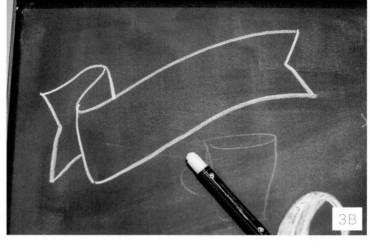

On the left and right side of "coffee," print some drink sizes along with a few syrup flavors. To do this, you'll want to use a random mixture of capital and lowercase letters and allow them to have some bounce, similar to the way we let our Faux Calligraphy letters bounce along a baseline sometimes. If you like, add a doodle of a coffee cup on each side of the center lettering and draw a border along the top and bottom of the board made of tiny coffee beans (ovals with lines through the center). In the top corners of the board, letter a few more flavors in Faux Calligraphy.

Draw a half-banner in each top corner, where you'll write "mocha" and "caramel" in Faux Calligraphy Print. Faux Calligraphy Print is a fun and easy font that builds on skills you already know. To create the letters, we follow the Faux Calligraphy skill of adding a second line to help us thicken parts of the printed letters. However, rather than doing this on every downstroke, we will keep things simple and just thicken the left side of each letter. To see the whole alphabet written in this style, check out page 160.

Banners are a fun accent to many hand lettered phrases, and they're easier to draw than they look. You'll start by making a squiggly line that resembles a flat "s" with a long tail. You can also do this in reverse to make your banner go the other way. This is the top of the banner. Draw a sideways "v" on each end. Then draw a short vertical line coming down from the bottom of the curve. Connect this line to the "v" at the end of your banner's tail. Finally, connect the other "v" about halfway down the vertical line and add a short vertical line to finish the fold (Image 3B). Once you have your banner complete, you can write a word inside! For a step-by-step look at how to draw these, check out page 166 in the Alphabet Reference Guide.

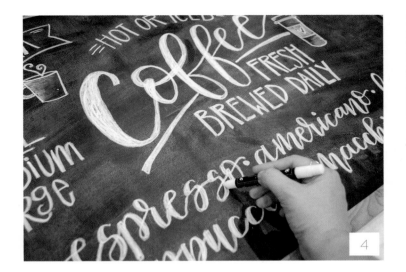

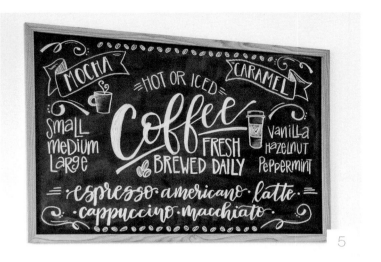

STEP 4: **Use erasable chalkboard markers or chalk to create your lettering.**

Keep in mind that you'll want to work from top to bottom and left to right when working with chalk if you are right-handed, because anything your hand touches as you write will smear or erase. (If you want to create more permanent art, you can opt for a white paint marker, which won't erase.)

You'll notice that to fill the empty spaces between some of my words, I added simple swirls and loops. There's no wrong way to draw these—just play around with your chalk until you get shapes you like!

PRO TIP: Working on an erasable surface is a great opportunity to try new things.

STEP 5: **Erase any guidelines or other unwanted marks.**

I find that a damp cloth or paper towel applied directly to the area will get rid of any marks you don't want to keep. Sealing the chalkboard isn't necessary, unless it's in an area where it could get rubbed or touched often and you want your artwork to be permanent. If you do choose to seal your chalkboard, simply spray the board with hairspray or a clear matte sealer to protect your work.

This chalkboard is perfect for a kitchen, a coffee bar area, a dining room or anywhere else you want to celebrate your love for coffee. Not a coffee drinker? Substitute words related to your favorite beverage, place or hobby.

FARMHOUSE-STYLE THROW PILLOW

WRITING TOOL: Heat Transfer Vinyl

SURFACE: Fabric Pillow Cover

TECHNIQUES: Faux Calligraphy (page 12), Caps-Lock Print (page 18), Bounce Lettering (page 23), Banners (page 44)

I once saw a meme that said, "Throw pillows are the stuffed animals of grown women." Pillows are soft, squishy and fun to collect. While solid pillows are great for adding pops of color to a room, pillows with words can become focal décor pieces. Adding a favorite word or phrase brings your personality into any room. There are several ways to create a pillow cover that features your own hand lettering, but my favorite method is using heat transfer vinyl. Heat transfer vinyl gives a professional-looking result that's permanent, machine washable and durable for daily use. The only downside is that it requires special equipment for the best results: an electronic cutting machine and a heat press or iron. If you don't have these tools, grab some permanent fabric markers or fabric paint and simply letter directly onto your pillow cover instead. Check out the projects for the lettered shoes (page 77) or the tote bag (page 97) for details on using fabric markers or paint.

- Blank cotton pillow cover in your choice of size (mine is 18" x 18" [45.7 x 45.7 cm])

- Pillow form in the same size as the pillow cover

- Cricut Explore Air™ 2 or other electronic cutting machine

- Heat transfer vinyl (also called iron-on vinyl)

- Cutting machine mat

- Scissors

- Cricut EasyPress™ 2 and mat or iron and towel

- Ruler

- Chalk or water-soluble marker

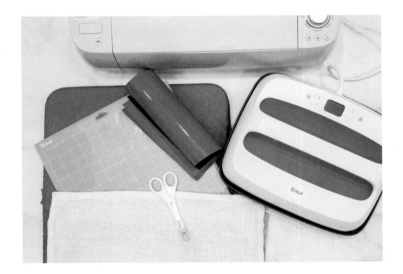

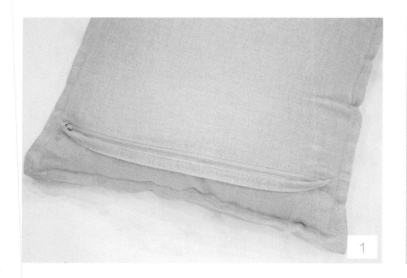

STEP 1: **Wash, dry and iron your pillow cover.**

For this project, it's much easier to work with a pillow cover than a stuffed pillow. Not only does the cover lay flat, but also you can simply remove it from your pillow form when you want to wash it or change your décor seasonally. One option is to purchase the form and the cover separately or to sew your own cover. Another option is to find a plain store-bought throw pillow with an easily removable cover. Look for one with a zipper, like this one I found at my local Target, or one with overlapping fabric in the back that allows you to slide the pillow form out.

STEP 2: **Create your design and load it into your cutting machine software (I use Cricut Design Space®).**

If you happen to have an Apple Pencil and a compatible device, the simplest option is to do your lettering digitally in an app like Procreate®. The Apple Pencil responds to pressure just like brush pens do, so it's ideal for hand lettering. There are many different brushes you can use to create all kinds of visual effects. If you don't have the ability to letter digitally, you can letter on a piece of paper and clearly photograph or scan your artwork.

For our sample design, I used the phrase "let's stay home." As an introvert, I'd pretty much always rather stay in my comfortable house with the people I love, so the sentiment is a good fit! To letter it, start by drawing a half-banner (page 44) and letter the words "let's stay" inside it. You'll want to print those words using capital letters for the consonants and lowercase letters for the vowels. Then, use Faux Calligraphy (page 12) to write the word "home" below the banner. Of course, if you prefer a different design, you can always feel free to make changes or come up with something that's totally your own.

STEP 3: **Upload your image and open it in your cutting machine software.**

If you're working digitally in an app like Procreate, save the file to your device as a PNG file with a transparent background, then open your cutting machine software and upload the file. If not, upload the photo or scanned image of your artwork into the software and use the editing tools to remove the white background. Then size the image to fit your pillow cover. The measurement grid in your software will help you make sure the design is straight and sized correctly. Now is the time to make any last-minute edits or changes to your image.

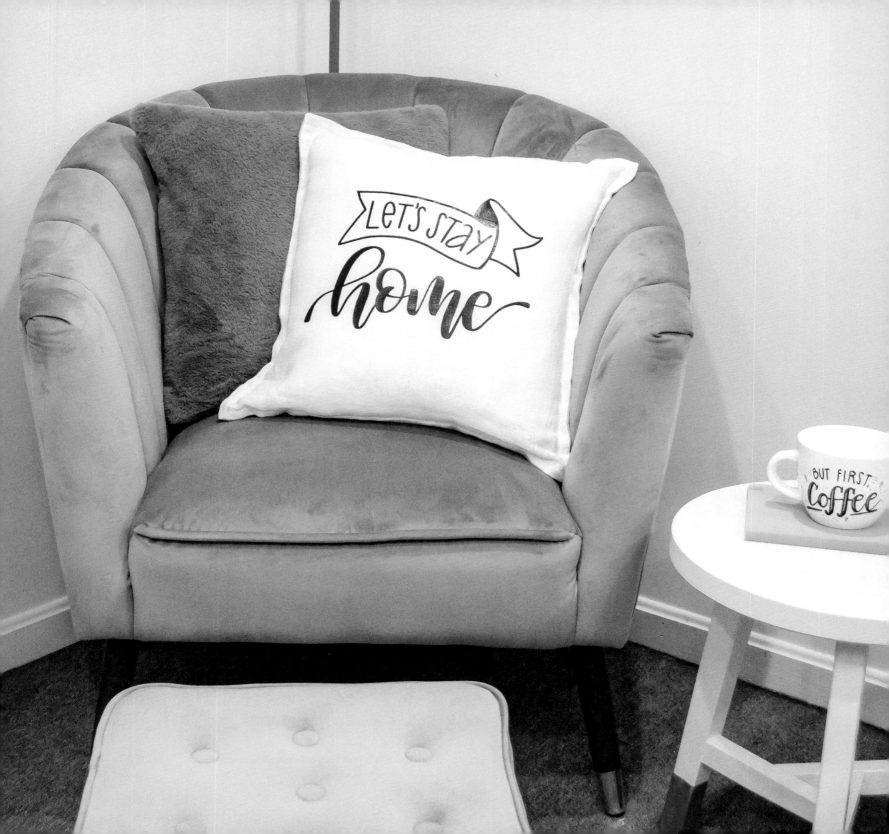

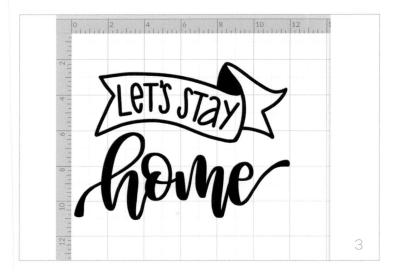

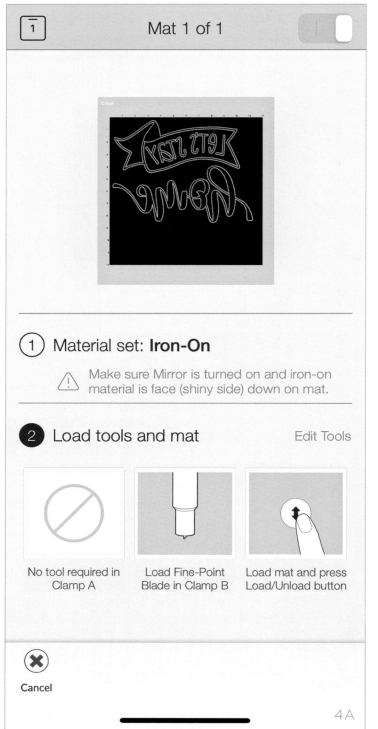

PRO TIP: Keep in mind that unless you want your words to go off the edges for stylistic reasons, you should avoid getting too close to the seams. When your pillow is inside the cover, the shape will change and may make large designs hard to read.

STEP 4: **Load your machine and begin the cut.**

First, place a sheet of heat transfer vinyl on your cutting machine mat with the shiny side down. You can find this type of vinyl in a huge variety of solid colors, as well as patterns and even glitter. Gently press it, shiny side down, onto the mat to adhere it in place and keep it from moving during the cutting process. Be sure that the dial on your machine is turned to Iron-On Vinyl so that it will use the appropriate cut settings for the material. Then follow the prompts in the software to send the design to your machine, load the mat and start the cut (Image 4A).

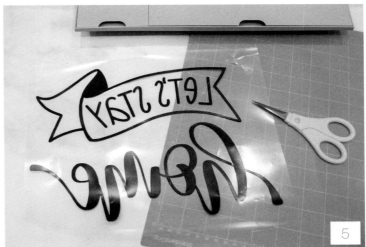

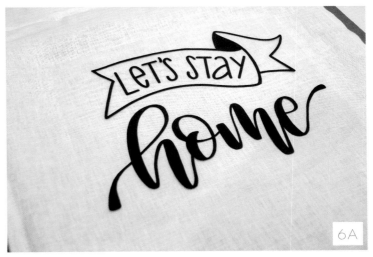

Be sure to check the Mirror box so that the design cuts backward. The part of the vinyl that's facing up is what fuses to the fabric of the pillow cover, so you want to cut the mirror image of your lettering (Image 4B).

STEP 5: **Weed your design.**

To do this, remove the vinyl from the machine mat, then gently peel away everything that isn't part of your design from the backing. Make sure to get the cut parts in the center of letters like "e" and "o." I can usually get everything off with my fingernails, but there are also tools, including tweezers and small hooks, that can be helpful for removing tiny pieces between letters. When you're finished, you should be left with your cut design, still attached to the backing.

STEP 6: **Apply your vinyl design to the pillow.**

First, lay the pillow cover flat on top of your Cricut EasyPress 2 mat. If you don't have one, you can substitute a folded towel and use an iron. Use a ruler to find the center of your pillow cover and make a very light mark using chalk or a water-soluble marker. This will help you center your

design. Make sure your EasyPress's heat is set to 315°F (157°C); or if you're using an iron, warm it to the highest temperature allowed for the fabric type (no steam). Press on the pillow cover to preheat the fabric for 5 seconds. Warming up the fabric will remove any moisture and help the heat transfer vinyl to fuse properly. Place the vinyl design on top of the pillow cover using your chalk mark as a guide (Image 6A) and apply even heat with the EasyPress 2 or the hot iron.

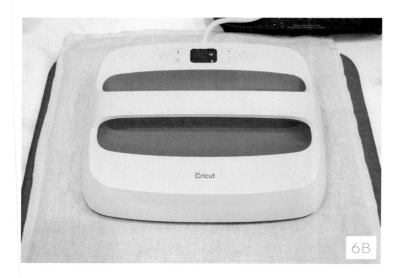

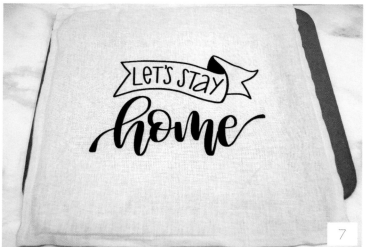

For a cotton or cotton-poly blend pillow cover like mine, apply light, continuous pressure for 30 seconds with your temperature set to 315°F (157°C) (or at the highest temperature setting your iron allows for the fabric type). Then flip the cover over and apply heat to the back side for another 15 seconds (Image 6B). Other types of fabrics require different times and temperatures, so be sure to check out the Heat Guide at cricut.com if you're using something other than a cotton-based pillow cover.

PRO TIP: While an iron can be used for this step, my absolute favorite tool is the Cricut EasyPress 2. It's available in four sizes, from mini up to 12 x 10 inches (30 x 25 cm) and has a built-in temperature gauge and timer. The dual heating elements and ceramic-coated plate provide dry, even heat at all times, unlike the standard iron, which creates steam and can vary in temperature across the plate as much as 200°F (93°C).

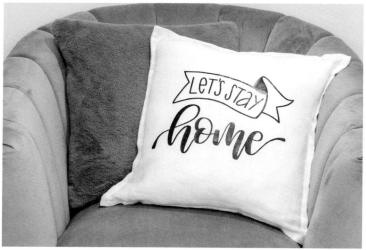

STEP 7: **Gently peel the clear adhesive backing from the pillow cover.**

Cricut brand iron-on vinyl is "warm peel" rather than "hot peel," which means you should allow it to cool off for 30 to 60 seconds before removing the clear backing. Other brands are "hot peel," meaning you can pull off the clear layer immediately. Either way, once you do remove it, you'll be left with your vinyl design permanently fused to the fabric cover.

All that's left to do is to place your pillow form inside the cover, then use it to accent your favorite couch or chair!

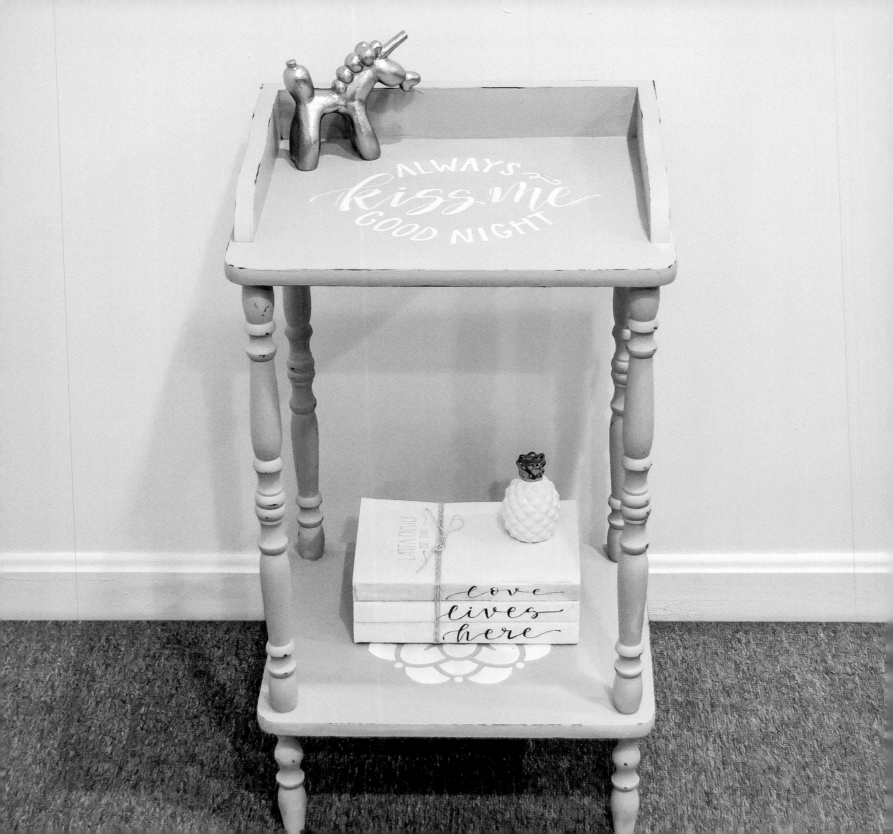

CHALK-PAINTED FURNITURE UPCYCLE

WRITING TOOLS: Paint Markers

SURFACE: Chalk-Painted Furniture

TECHNIQUES: Caps-Lock Print (page 18), Faux Calligraphy (page 12), Chalk Painting

There's something special about upcycling a piece of furniture and giving it new life. Painting, distressing and even stenciling furniture is a popular trend, but what about lettering? Adding hand lettering to furniture may sound strange at first, but I promise it can add a gorgeous, priceless touch. Let's look at the best practices for lettering on furniture as well as how to prepare it and protect it from the wear and tear of everyday use. This project uses two of our lettering fonts arranged in the shape of a circle to create a side table with a sweet message. My table is a perfect fit in our bedroom, and it was a great deal for just $7.99. Plus, it reminds me that no day is complete without a goodnight kiss!

YOU'LL NEED

- Pencil and eraser
- Piece of wooden furniture
- Chalk paint in 3 colors (1 color for the furniture piece, 1 color for the stenciled image and 1 color for distressing)
- Chalk paint–specific paintbrush (or large regular paintbrush)
- Stencil
- Painter's tape
- Stencil brush
- Fine-tip paint marker
- Wooden layering block (optional)
- Clear wax
- Wax brush or soft, lint-free cloth
- Soft cloth

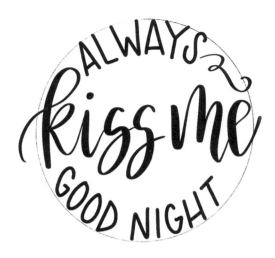

1

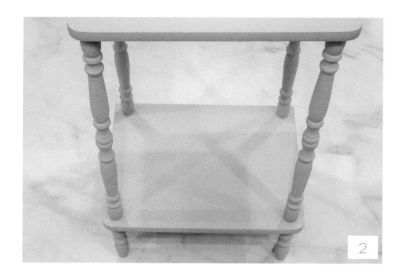

2

STEP 1: **Plan your lettering design.**

Take some time to sketch a plan with pencil on the blank page at the end of the tutorial (page 61). It can be just like mine or something totally unique. Since my piece is going to live in our bedroom, I chose the saying "always kiss me good night." To make it visually interesting, let's create the design in the shape of a circle. Write the word "always" in an arch to form the top of the circle and the words "good night" along a curve to form the circle's bottom. That will leave just enough room for the words "kiss me" to fill in the center. My font choices were Caps-Lock Print (page 18) for the smaller words and Faux Calligraphy (page 12) to emphasize "kiss me."

STEP 2: **Clean your furniture piece, then apply a base coat of chalk paint.**

My favorite thing about chalk paint is that you don't have to do any prep to your surface other than making sure it's clean, dust-free and dry. There's no sanding or other prep work required, unless the furniture piece is in need of some sort of repair. The piece I found was a bargain at my local Goodwill, a cute little night table that's the right size to go on my side of the bed.

PRO TIP: Thrift stores and yard sales are great places to find gently used furniture that's perfect for upcycling. Also, be sure to keep an eye out for roadside finds, especially if your town has a bulk trash pickup day.

You can use any type of paintbrush, but I personally prefer to use one that's made just for chalk painting, because it helps work the paint into the surface evenly and provides good coverage. With chalk paint, you'll want to apply numerous thin coats and let the paint dry completely between applications. If you apply too much paint at once or try to paint a new coat over a wet one, the paint will pull itself back off and you'll have to start over. I was able to cover my table with just two coats of FolkArt® Home Decor™ Chalk Paint in Parisian Grey. Other pieces I've painted have required three or four coats, depending on the original color of the wood and the color I'm painting on top.

3

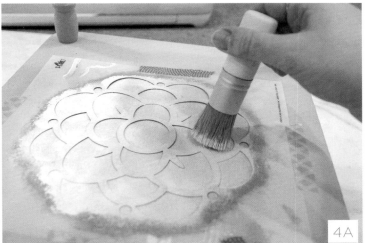

4A

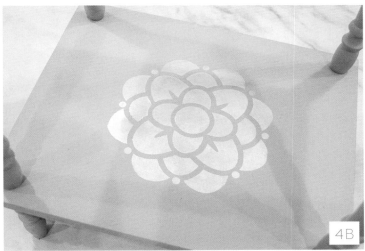

4B

STEP 3: **Position your stencil and secure it in place with painter's tape.**

Only move on to stenciling when your base coats of paint are totally dry. Make sure to use enough tape around the edges to cover up the surface anywhere your brush might accidentally touch while you're working. I chose a large flower stencil to go in the center of the bottom portion of my table. There are all kinds of stencils you can choose from, including geometric patterns, animals, florals and symbols. Or you can choose not to use a stencil at all. I decided to use one because it added visual interest to the bottom part of my table without distracting from the lettering I wanted to do on the top.

STEP 4: **Use a stencil brush to fill the open areas of the stencil with paint.**

It may be tempting just to use any brush you have on hand, but a stencil brush is specially designed to help you get the best possible results. It's round and full, with bristles that create a flat surface to evenly distribute the paint (Image 4A).

When you're finished, remove the tape and stencil while the paint is still wet (Image 4B). Otherwise, the stencil may stick to the piece as it dries and pull paint off when you try to remove it.

PRO TIP: When stenciling, less is more. The more paint you have on your brush, the easier it is for paint to bleed underneath the stencil and prevent you from getting a crisp image. Instead, I like to put my paint on a paper plate, load my brush lightly then tap it on the plate to off-load paint until it's almost dry. Then I tap the brush up and down inside the open parts of the stencil. You'll have to reload your brush frequently, but you'll get a nice, clean image.

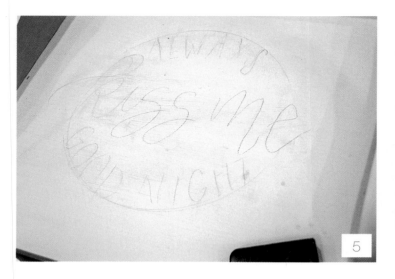

5

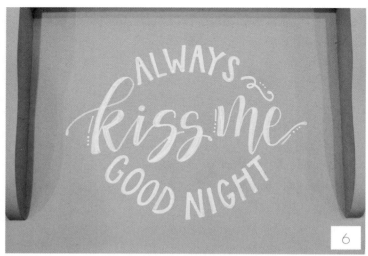

6

STEP 5: **Lightly pencil in your design.**

Test your pencil and eraser in an inconspicuous spot of the piece to make sure it erases cleanly. Then sketch your word placement. My design is based on a circle, so I started by very lightly tracing a small paper dessert plate. Then I penciled in the words "always" and "good night" around the upper and lower curves in Caps-Lock Print. Finally, I sketched where the words "kiss me" would go in Faux Calligraphy across the center.

STEP 6: **Trace your lettering with paint marker.**

I used a white paint marker on my piece, but you can use whatever looks best with the paint color you chose and your own home décor style. Once the marker is dry, erase any pencil marks you can still see.

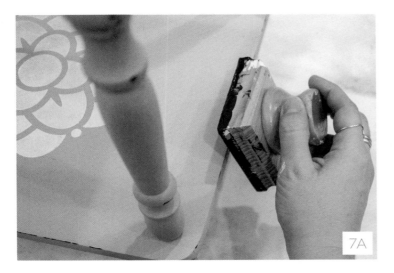

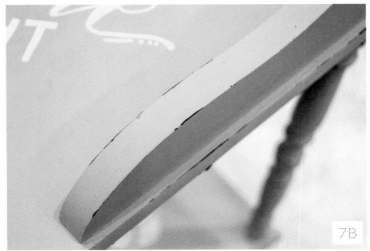

7A

7B

STEP 7 (OPTIONAL): **Add a distressed look to the project to make it look lovingly worn over time.**

Distressing a piece of furniture is meant to give it an aged look, like a family heirloom that has been cared for but used for a number of years. Some people are not fans of this style, so this step is totally optional. Personally, I like doing it to my furniture because then when actual scratches or damage occur thanks to my boys or my pets, it's not a big deal! In fact, I rarely notice. Many people try to achieve this effect by sanding paint off at the corners and edges to reveal the original wood or paint, but I prefer to add paint instead. Applying small amounts of dark brown, gray or

black paint in those areas gives the illusion of paint being removed without the mess of sanding or changing the structure of the piece. To do this, load a small amount of paint onto a wooden layering block. Gently run the block over the edges and corners of the piece, along with any other areas that would naturally experience the most wear and tear from daily use (Image 7A).

You can control the amount of distressing based on how much paint you use and how liberally you apply it. I wanted mine just lightly distressed so it looked well loved, not like it was dragged down a gravel road by a pickup truck (Image 7B).

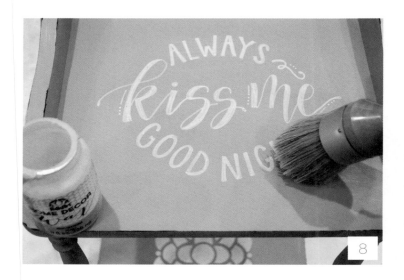

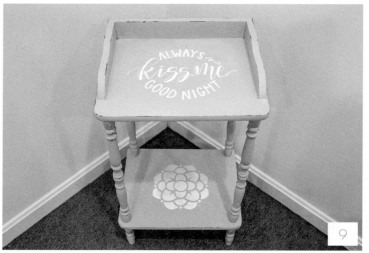

STEP 8: **Once the paint and lettering are dry, seal your project with clear wax.**

This will protect your work and allow you to clean the piece by wiping it down with a damp cloth. You can do this by applying the wax to a special wax brush and rubbing it in a circular motion all over the piece. If you don't have a wax brush, you can use a soft, lint-free cloth instead. Gently rub the wax into the piece until the entire surface is covered.

PRO TIP: One of my favorite ways to apply wax is by using an old but clean sock! I place it on my hand like a mitten.

STEP 9: **Allow the wax to cure per the manufacturer's instructions, then buff it to your desired sheen with a soft cloth.**

Once the wax is finished, your piece is ready to display and use in your home.

Apparel

We've seen how much fun it is to decorate our homes with DIY lettering projects, but what about using our hand lettering to decorate ourselves? Our clothing is like a canvas, and so are our shoes, our jewelry, our phone cases, our bags and everything else we wear or carry with us. They can tell others about our preferences, our hobbies, our passions and our moods. The next eight projects we'll be creating will help us use our hand lettering skills to make wearable art.

You'll explore learning a new watercolor technique to help you create a statement necklace, applying metallic effects to a purse and using infusible ink to customize a T-shirt. Plus, we'll see how fabric paint can transform a plain pair of slip-ons and learn to use embroidery to make our lettering come to life on fabric in a brand-new way!

Ready? Let's get started with a gorgeous piece of hand lettered jewelry!

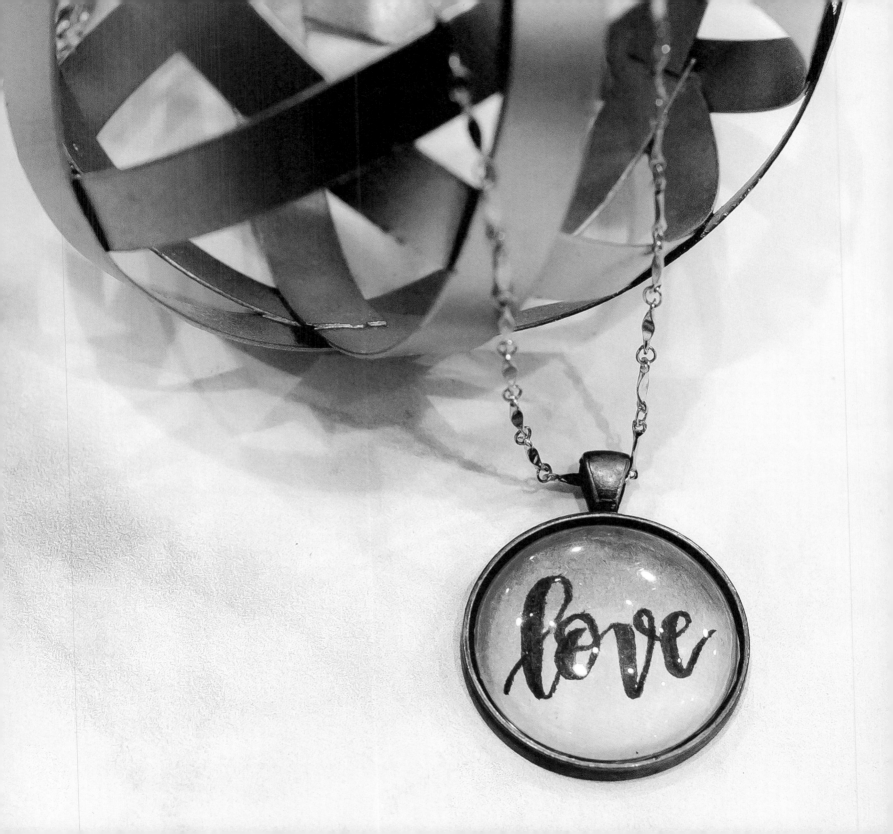

WATERCOLOR NECKLACE

WRITING TOOL: Waterproof Fine-Tip Marker

SURFACE: Hot-Press Watercolor Paper

TECHNIQUES: Faux Calligraphy (page 12),
No-Mess Watercolor

Lettering can become wearable art with this modern version
of the traditional locket. Instead of inserting a photo, we'll
be placing hand lettered artwork inside a metal shape.
By using a bezel rather than a locket that closes, your art
will be on display for everyone to see. This project doesn't
require any wireworking or jewelry-making skills, especially
if you use a ball chain or precut chain with a clasp already
attached. If you want to measure and cut a length of link
chain and add your own closure, you'll just need wire cutters
and a pair of pliers to open and close a few jump rings.
Either way, this necklace is doable even if you've never
made jewelry before. The best part is that each necklace
you make will be one of a kind.

YOU'LL NEED

- Pencil and eraser

- Bezel pendant tray with glass cabochon in your choice
 of shape and size (mine is a 1" [25-mm] round piece)

- Hot-press watercolor paper

- Tombow Dual Brush Pens or other water-based markers
 (I used Tombow Dual Brush Pens 725, 665 and 606)

- Nonabsorbent surface (such as a plastic sandwich bag)

- Aqua pen filled with clean water

- Monoline drawing pen (I used a Tombow MONO
 Drawing Pen)

- Scissors

- Mod Podge® Matte formula

- Necklace chain

- Wire cutters, pliers, jump rings and clasp (optional)

PRO TIP: Hot-press watercolor paper is different than the
"regular" cold-press watercolor paper that's usually found
in art classes and stores. It's still specially formulated to
respond well to water, but the different pressing process
gives it a very smooth feel rather than the bumpy, textured
feel that cold-press watercolor paper has. This is much
better for lettering, because the pen won't snag and our
letters can be neat, clear and even. I typically order mine
from Amazon; a twenty-sheet pad by Fabriano is about
ten dollars.

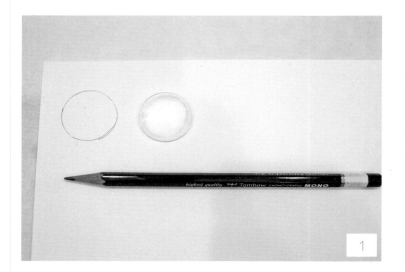

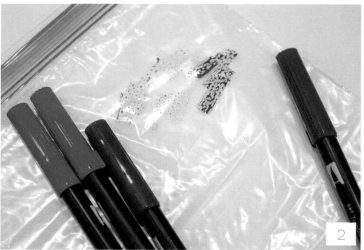

STEP 1: **Use a pencil to trace the shape of the glass cabochon onto your hot-press watercolor paper.**

You won't want this to show, so use pencil and press very lightly. This will give you a shape to work with that will fit inside your bezel. I like to trace multiple shapes at once, so that I have extras to use in case I make a mistake. You can also create more than one necklace at a time if you like.

STEP 2: **Scribble your choice of colored markers onto the nonabsorbent surface.**

Because the plastic doesn't absorb the color, the ink will pool, making it easy for you to pick up with your aqua pen. Each color should have its own area on the plastic, allowing you to use them separately or to mix them together on your brush. To recreate the sample, you'll want to use a pink, a magenta and a purple marker (such as Tombow Dual Brush Pens 725, 665 and 606).

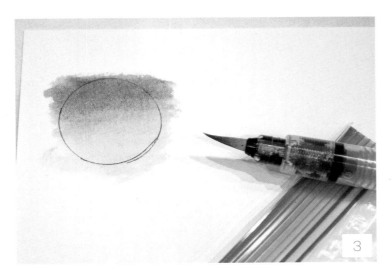

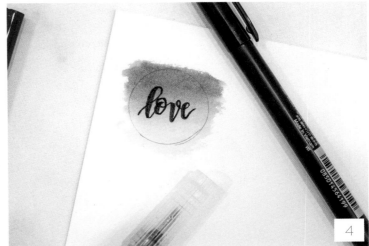

STEP 3: **Run the tip of your aqua brush through the colors of your choice, then use the aqua brush to paint inside the traced shape.**

The aqua brush combined with the marker will give you a beautiful faux watercolor effect. You can fill in the shape with one color, blend several colors for an ombré background (like I did) or even paint tiny details like florals and hearts. Experimenting with different designs and colors is one of the most fun parts of this project! Each one will give you a unique piece of art.

To create this particular effect, load your brush with ink from each of the three colored pools of ink you created in the previous step, allowing the colors to mix on the brush tip. Begin at the top of the circle, filling it in with color. As you get closer to the bottom, the ink will become lighter, creating an ombré effect.

STEP 4: **When the background is completely dry, use your favorite waterproof fine-tip marker to add a hand lettered word or phrase.**

It's important to make sure your marker is waterproof, or else it will bleed when you write on top of the watercolor background. I kept things very simple for the lettering and used Faux Calligraphy (page 12) to write the word, "love."

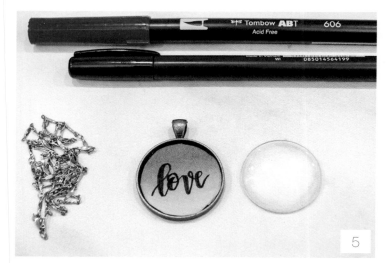

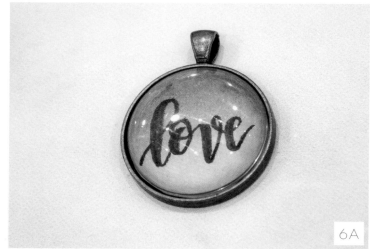

STEP 5: **Use scissors to cut out your traced shape and adhere it in the bezel tray.**

Since the pencil line was on the outside of the cabochon, the shape is slightly bigger than it needs to be in order to fit inside the bezel. Cutting just inside of your pencil markings will help get it closer to the correct size. Try setting it inside the bezel tray; if it still doesn't fit, trim it as necessary.

Apply a very thin coat of Mod Podge to the inside of the bezel tray, then place your cut shape on top.

In this case, less is more. The coat of Mod Podge should be so thin you can't even see it. We don't want to warp the paper or have any excess adhesive seeping out from the edges—we want just enough to adhere the paper in place. You can do this with a brush if you like, but I just use my index finger. Press the paper shape down firmly, then let the Mod Podge dry.

STEP 6: **Add the cabochon and finish your necklace.**

First, apply another very thin coat of Mod Podge to the back of the cabochon, then place it on top of your artwork. Although it may look a bit cloudy when wet, the Mod Podge will dry clear and your artwork will be visible under the glass. Matte Mod Podge is my favorite formula for this project, because when it dries you won't be able to see it at all. However, if you want to add some sparkle, you can try using one of the glitter formulas instead.

Once the Mod Podge is dry, slide the pendant onto your necklace chain. If you chose to use a ball chain or a precut chain with a clasp already attached, your work is finished as soon as you add the pendant to it. Otherwise, you will need to measure your desired chain length and cut the chain using wire cutters. Open a jump ring and attach it to one end of the chain. Then choose a clasp and open the jump ring attached to it. Attach it to the other end of the chain (Image 6A).

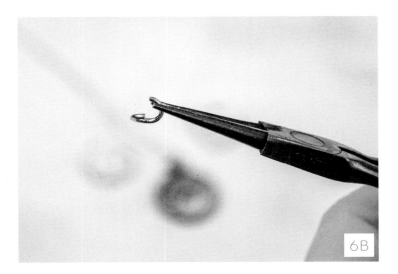

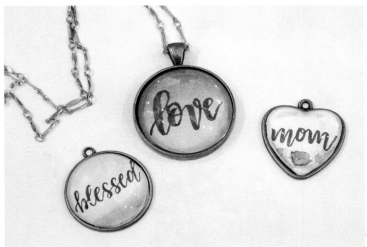

PRO TIP: To open a jump ring, use pliers to gently twist one end toward you while pushing the other end away. To close it, simply twist the ends back to their original positions until you hear a slight click. If you pull the ends apart rather than twisting them, the ring will lose its circular shape and won't close securely (Image 6B).

As soon as the Mod Podge has dried and cured, your necklace is ready to wear or share! If you're anything like me, making one of these won't be enough; you'll want to experiment with lots of different designs and phrases to make something special for just about everyone you know. Above are a few other designs created with the same technique to inspire you.

PERSONALIZED WALLET

WRITING TOOL: Paint Pen

SURFACE: Leather or Faux Leather

TECHNIQUES: Faux Calligraphy (page 12), Bubble Letters, Dots and Diamonds

All of us have a few things we just can't seem to get enough of, right? One of my sons feels this way about Pokémon cards, while the other hoards baking supplies. As for me, I believe a girl can never have too many purses or shoes. I like being able to choose a different purse, clutch or wallet for every occasion. I want something that works well with my outfit and is functional for whatever I happen to be doing. While I do have a few neutral bags, I love a good statement purse. And what better way to make a statement than to letter it yourself? Writing a favorite phrase on a wallet or bag is not only a fun, legal form of graffiti, it's also a perfect way to communicate everywhere you go without ever saying a word.

YOU'LL NEED

- Wallet or purse

- Rubbing alcohol and cotton ball or soft cloth

- Pencil and eraser

- Fine-tip metallic acrylic paint markers (I used gold and silver)

- Leather varnish or clear acrylic sealer

- Paintbrush

PRO TIP: You don't have to spend a fortune to get a bag that's perfect for lettering! I got this one from the bargain section at Target. You can also find purses, including designer ones, in great condition for awesome prices at thrift shops and yard sales.

STEP 1: **Clean the surface of the purse or wallet with rubbing alcohol.**

This will remove not only dust but also any grease or other buildup. Doing this will help your paint to adhere properly.

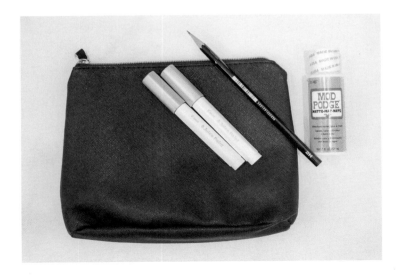

2

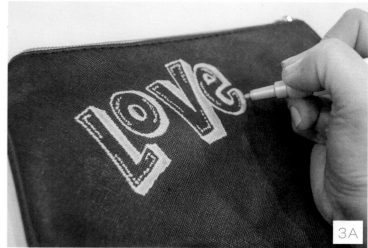

3A

STEP 2: **Plan your design.**

Although you won't be able to use pencil on the actual bag, having a plan on paper will help ensure that you create a design you love. I recommend measuring the bag, then marking off that size and shape on the practice page at the end of this tutorial (page 75). Play around with the space you have and the message you want to letter. Try different combinations of fonts and sizes until you get something you love.

STEP 3: **Begin drawing your letters on the purse with the paint marker.**

For my design, I chose to write "love louder" as a reminder to myself that I want to consciously make sure I'm doing things that show love and kindness in my daily life. So that I didn't have to worry about getting my letters perfectly straight, I chose to tilt my design and work on a diagonal. I wanted "love" to be the emphasis, so I wrote it in Bubble Letters. Remember drawing Bubble Letters in your notebook when you were a kid? That's exactly what we're doing here. I started by drawing the outline of each

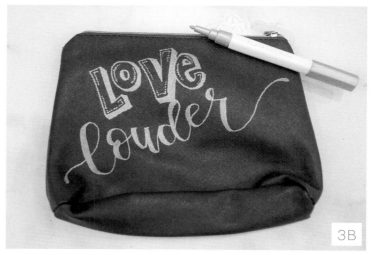

3B

letter, then I added some drop shadows. Finally, I added some stippling inside each letter to give the suggestion of highlights (Image 3A). For a look at the whole alphabet written in Bubble Letters, head to page 161.

Next, I used Faux Calligraphy (page 12) to write "louder" below the word "love" (Image 3B). Then it was time to add some embellishments.

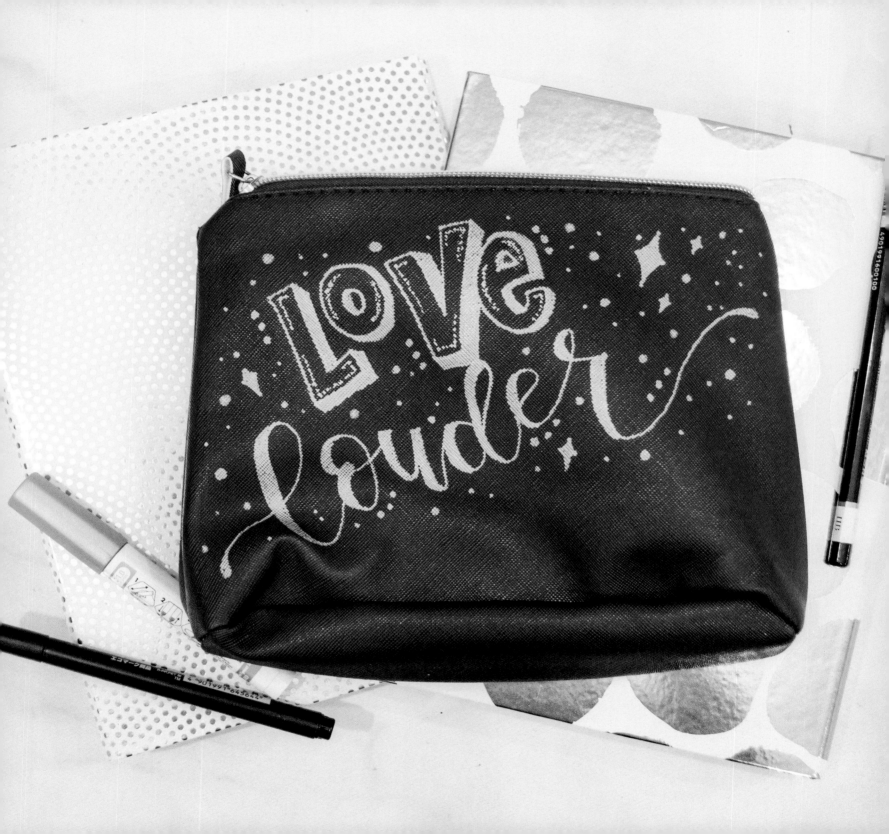

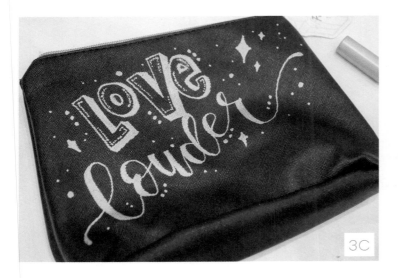

3C

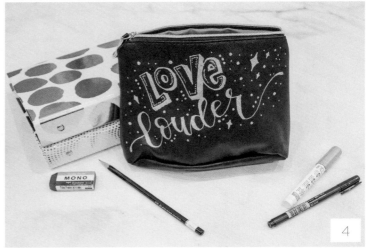

4

One thing I enjoy doing to fill empty space around words is adding geometric fillers like dots and diamonds. Since the diamonds are the largest of the embellishments, I place a few of them first. Typically, I stick with 3 to 5 of these per design and space them out somewhat evenly. When the diamonds are finished, I move on to drawing a few circles in the remaining empty space near my phrase. Next, I add circles that are a bit smaller. Sometimes I put two of these smaller circles near a larger one to form a little grouping of three. Then I go back and add the smallest dots, usually just one touch from the tip of my marker. There's no rule regarding how many dots you use or where you place them. The idea is just to add some accents to fill up the open spaces. Some people like to use them all over the entire surface of the project, while others keep them close to the lettering like I did in my design. I did some of my embellishments in gold, then added a few in silver for a bit of contrast (Image 3C).

STEP 4: **Seal your artwork with a coat of leather varnish or clear acrylic sealer.**

This will prevent your design from scratching off or fading with daily use. Make sure the paint is completely dry before applying the sealer with a paintbrush, or else it could ruin all your hard work by smudging the wet paint. You can use any type of finish you prefer. I personally like matte, because it maintains the original look of the project.

It's that simple! Once your design is sealed and dry, your purse or wallet is ready to use on your next shopping trip.

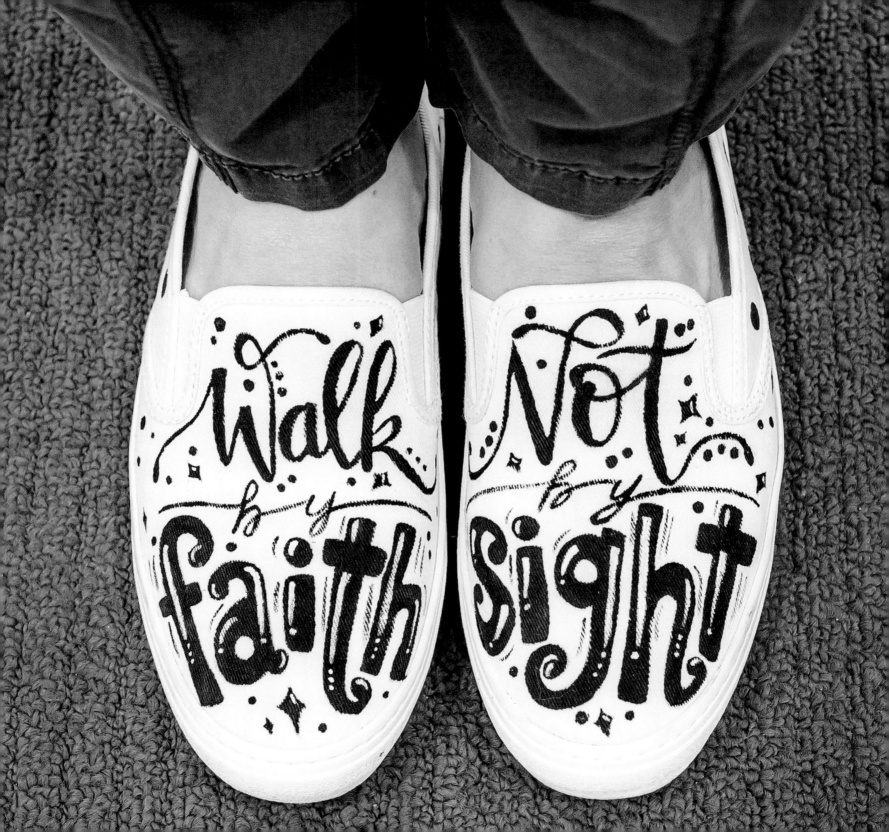

FABRIC-PAINTED SHOES

WRITING TOOL: Fabric Paint

SURFACE: Shoes

TECHNIQUES: Faux Calligraphy (page 12), Elongated Script (page 38), Lowercase Bubble Letters (page 72), Dots and Diamonds (page 74), Highlights

Cinderella is proof that a new pair of shoes can change your life. I'm of the opinion that shoes are the finishing touch that can make the difference between a good outfit and a fabulous one. And of course, what could be more fun than creating and wearing a pair of shoes that is a walking work of art? With the help of flexible, permanent fabric paint, I'm going to show you how you can turn a plain white pair of slip-ons into statement accessories. The best part is that they're designed for wear and once they're heat-set, they can be wiped clean or even machine washed. From checkered or floral patterns to intricately lettered designs, there's no limit to what you can create! If you like to sparkle, you can even add a touch of glitter fabric paint to make your shoes shine.

YOU'LL NEED

- Pencil and eraser
- 1 pair of canvas shoes
- Fabric Creations™ Soft Fabric Ink paint in your choice of colors (I used black and white)
- Fine detail paintbrushes
- Stencil
- Iron or Cricut EasyPress™ Mini
- Scrap fabric or pillowcase

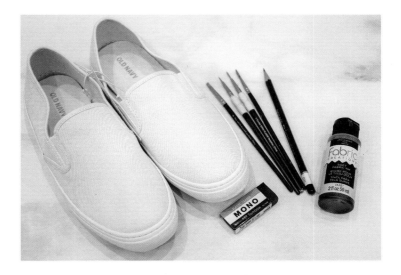

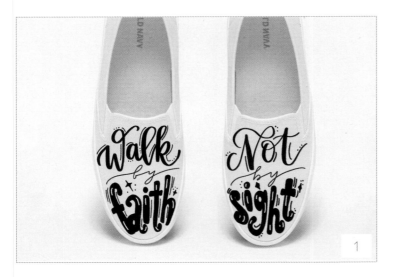

STEP 1: **Sketch a plan of your design.**

Unlike most of our projects, which have flat surfaces for lettering, your shoes have many sides to consider as you come up with your design. I suggest sketching shapes on your paper (like the blank space on page 82) to represent the top and sides of each shoe, so you can think about it from all angles. Or, if you happen to have an iPad and Apple Pencil, you can go high-tech with your plan. I downloaded the image of my shoes from the retailer's website (oldnavy. com), then imported it to Procreate. This allowed me to simulate lettering on the shoes to see exactly what my design would look like in real life.

As far as design, some ideas to consider are a favorite quote or song lyric, or a special place or idea and words related to it, like we did on our Subway-Style Chalkboard Art (page 41). You'll also need to decide whether you want the shoes to match or to work together as a pair. I chose to use the Bible verse "walk by faith, not by sight" (2 Corinthians 5:7 KJV), splitting it between the two surfaces.

I chose a combination of Faux Calligraphy (page 12), Elongated Script (page 38) and lowercase Bubble Letters (page 72) to write the words on the top of each shoe. I also planned to add embellishments—like dots and diamonds (page 74) and highlights—and to decorate the sides of the shoes with polka dots.

STEP 2: **Lightly outline your design on the surface of your shoes with a pencil.**

Don't worry, you'll be painting over the pencil lines, so they won't be visible. If any of these lines remain after your painting is complete, you can easily erase them. Remember, it's a good idea to test your pencil in a small, unnoticeable spot first, just to make sure your particular pencil markings are easy to remove from your shoes.

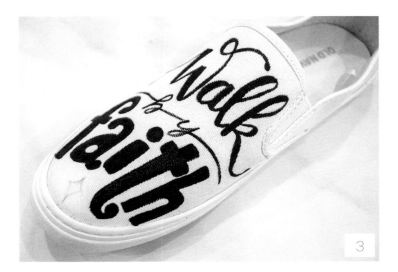

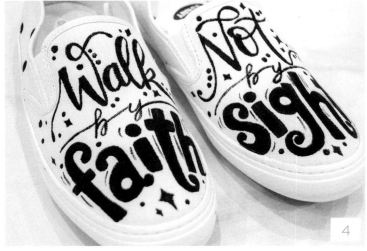

STEP 3: **Use fabric paint and fine detail paintbrushes to fill in your letters.**

I started at the top of the design and worked my way down. The smaller the paintbrush, the easier you'll find it to get your details exactly the way you want them. You can use any color scheme you like for your lettering. Personally, I chose to stay neutral and use black and white so I can wear my shoes with any outfit.

PRO TIP: While there are many fabric paints on the market, Fabric Creations Soft Fabric Ink paint is my favorite for projects like this because it stays incredibly flexible even after it dries, so your shoes are still as comfy as ever.

STEP 4: **Add dots and diamonds in the empty spaces around your lettering.**

Using the handle end of your paintbrush is a great way to get small round dots. Just flip your brush upside down, dip it into the paint and lightly tap it on the surface of the shoe. You may want to practice this technique on scrap paper a few times to get a feel for it before trying it on your project.

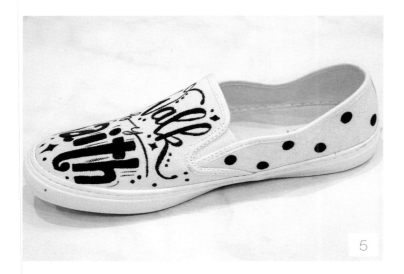

5

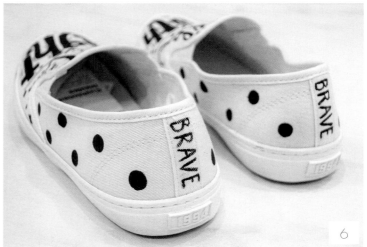

6

STEP 5: **Draw circles along the sides of each shoe, then fill them in with fabric paint.**

I actually found a stencil that had the right size circle as part of its design and used my pencil to trace it six times on each side. Your polka dots can be any size, and you can use any number of them. To fill them in, a fine detail paintbrush will do the trick nicely. I continued using black paint, but other colors work too!

STEP 6: **Pencil in a short word on the back of each shoe and trace it with fabric paint.**

Since the backs of my shoes had this perfect little thin section of canvas, they were just asking for a secret word! I chose "brave" and printed it in capital letters.

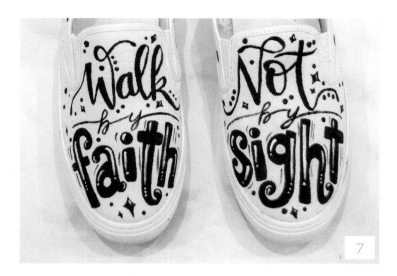

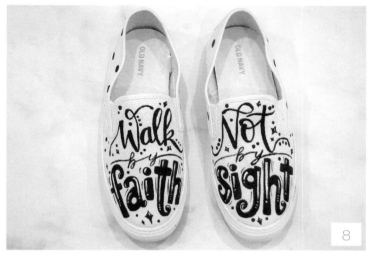

STEP 7: **Add highlights with white fabric paint.**

Make sure your first layer of paint is completely dry, then add white highlights wherever you'd like some. I used them on the words "faith" and "sight" as well as on the little diamond-shaped embellishments. To create highlights on letters, simply draw a line on the downstrokes of the letters. I usually like to leave a little extra space at the top and bottom of each downstroke to make the highlight stand out. I also added some small white dots below the highlight lines for extra embellishment.

STEP 8: **Heat-set the paint.**

Allow the shoes to dry overnight or for 24 hours, then heat-set the fabric paint. Turn your iron or a heat tool like the Cricut EasyPress Mini to the hottest setting allowed for the type of fabric your shoes are made of. Then place a piece of scrap fabric or a pillowcase on top. Without using steam, press the painted area for 15 seconds, then lift the heat source and move to another section. Continue this process until the entire design area has been heat-set.

Once your paint is heat-set, your shoes can be spot cleaned or washed, either on the gentle cycle in a machine or by hand in cold water. Wherever you choose to wear them, you're sure to make a statement!

CUSTOM PHONE CASE

WRITING TOOL: Permanent Adhesive Vinyl

SURFACE: Plastic Phone Case

TECHNIQUES: Straight-Line Script, Bounce Lettering (page 23)

For most of us, our phones are an essential part of everyday life. We use them to make phone calls, to text, to interact on social media, to play games and to work. Our phones have replaced paper maps, giving us directions. And for many of us, they've replaced our alarm clocks and calendars too. We take them everywhere we go. Why not take our lettered art and use it to personalize the accessory that's always with us? For this project, we're going to be using permanent adhesive vinyl and an electronic cutting machine, such as a Cricut, to create an original hand lettered design that sticks to a plastic phone case like a decal. Just so you know, nothing will stick to a silicone phone case—trust me, I learned the hard way. Are you ready to personalize your case? Let's get going!

YOU'LL NEED

- Markers and paper or iPad Pro and Apple Pencil
- Hard plastic phone case
- Cutting machine software (I used Cricut Design Space)
- Ruler or measuring tape
- Permanent adhesive vinyl
- Cutting machine mat
- Cricut Explore Air 2 or other electronic cutting machine
- Scissors
- Transfer tape
- Cricut scraper tool

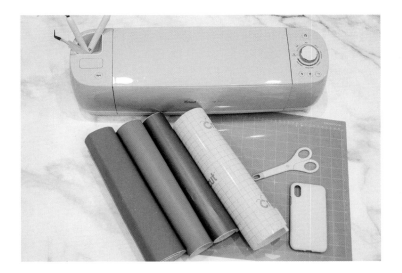

1

2

STEP 1: **Plan and create your design.**

Since I primarily use my phone for work, I decided to go with a little reminder for myself to "work hard, pray harder." The lettering style I used is something I like to call Straight-Line Script. It's a cursive-style font with thick downstrokes like what we do in our Faux Calligraphy (page 12) and Brush Script (page 148), but unlike that style, it has no loops. Instead, where you'd normally find a loop (like the stem of a "b," "d," "h" or "l"), you'll use a straight line instead. Also, you won't use loops when finishing letters like "o," "v" or "w." This gives us a totally different look, just by changing one thing! To see the whole alphabet written in Straight-Line Script, check out the resource on page 162. Using the bounce lettering technique (page 23) works with this font too, so don't be afraid to let your letters drift above and below your imaginary baseline as you write. As always, you are welcome to imitate my design for your own project, or you can letter anything you want. Since it's your phone case, you want the message to be a reflection of who you are.

Creating your design can be done in two different ways, depending on what supplies you own. If you happen to have an iPad that's compatible with the Apple Pencil, you can create your design digitally in an app like Procreate. Simply letter your design however you'd like, remove the background

layer and save your art as a PNG file. If you don't have these tools, the other option is to create your lettering by hand with markers and paper, then photograph or scan your artwork. No matter which option you use, I suggest tracing your existing phone case first to give you an idea of the dimensions you'll be working with. Create your design within that space to make sure it will fit your phone case properly.

STEP 2: **Load your image into the cutting machine software.**

I use Cricut Design Space, so some of the terms and instructions I use may be specific to that program, but other cutting machine software has similar capabilities and functions too. If you're working with a digital file from Procreate, all you have to do is upload it into Design Space and save it as a cut file. Import it onto a canvas and it's ready to go. If you're working with a photo or scanned image, upload the image. You'll be prompted to remove all the white background areas that aren't part of the design so that the software can create the right type of file.

Once your image is on a new canvas in the software, measure your phone case with a ruler or measuring tape, then resize the image to fit. Make sure to take into account things like your phone's camera and any other cutouts in the case that could interfere with the design.

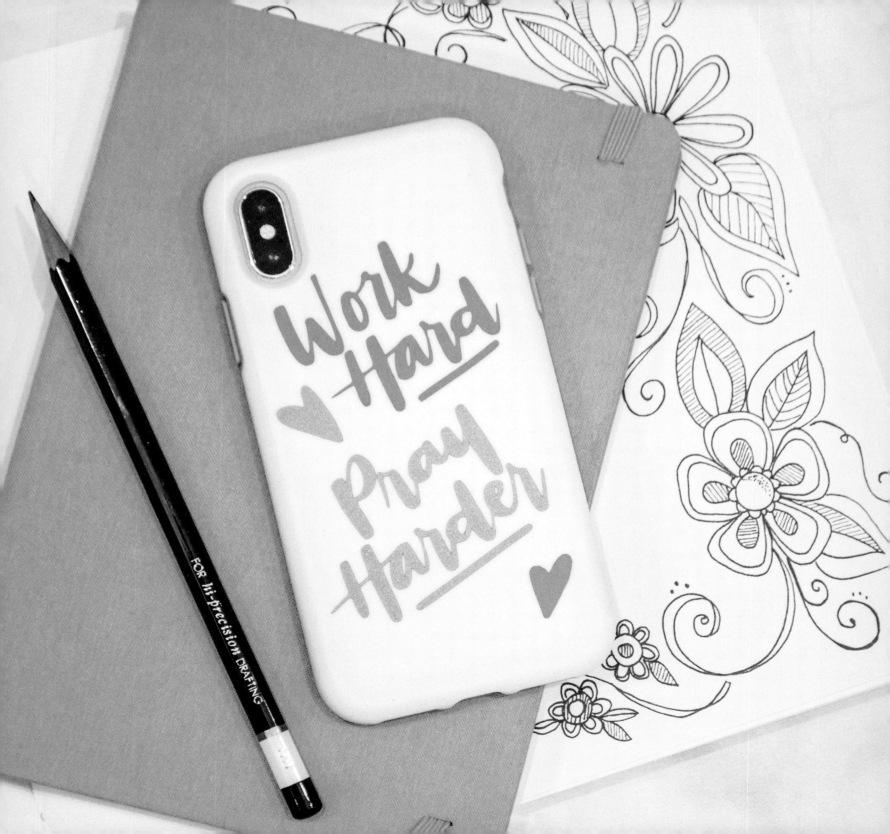

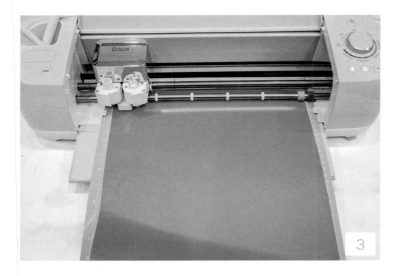

STEP 3: **Press a piece of permanent vinyl onto the machine cutting mat with the colored side facing up, and load it into the machine.**

The mat is adhesive, so it will hold the vinyl in place for you while the machine cuts.

STEP 4: **Send the file to the machine and let it cut.**

Make sure the dial is turned to Vinyl, then let the machine work its magic. When it's finished, unload the mat and remove the vinyl. If you want to use different colors for different parts of your design like I did, reload the mat with another color of vinyl and repeat steps 3 and 4.

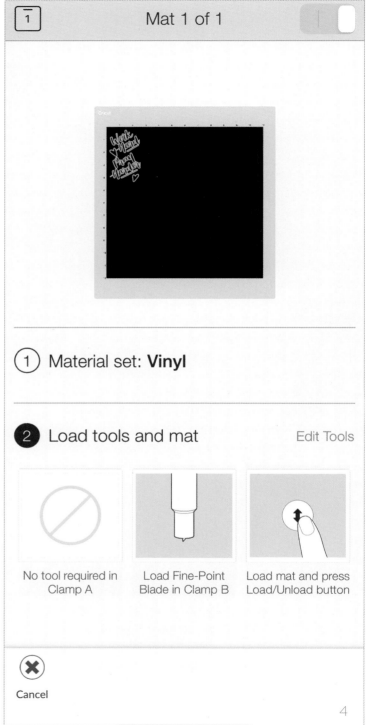

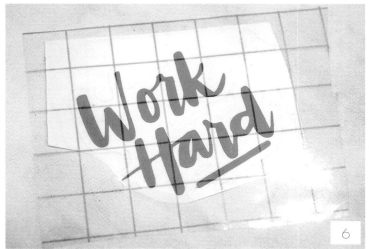

STEP 5: **Cut and weed your design.**

Use scissors to trim away the vinyl around the part of the design you're using, then peel all of the excess vinyl from the backing. Make sure to remove the centers of letters like "a" and "o." This should leave you with only your lettering on the paper backing.

STEP 6: **Apply a piece of transfer tape on top of your weeded design.**

Transfer tape is a sticky, clear material with grid lines on it to help you align and transfer your design to a surface. Remove the paper backing, then adhere it on top of your design. Peel off the backing from the vinyl, which will leave you with just the transfer tape and the vinyl itself.

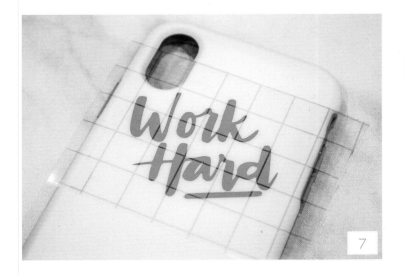

7

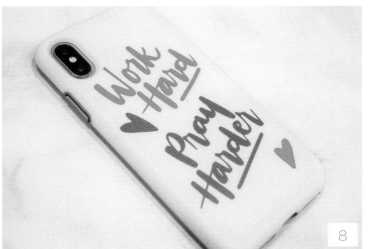

8

STEP 7: **Press the transfer tape and vinyl design onto your phone case.**

Place it lightly first, so that you can lift and reposition it if necessary. Then, when you have the design where you want it, firmly rub the top of the transfer tape to help the vinyl adhere to the case. You can use the Cricut scraper as a burnishing tool to help with this step.

STEP 8: **Carefully peel off the transfer tape.**

If the vinyl starts to lift up with the tape, try burnishing it a bit more. Peel slowly, and use your finger to press down any vinyl that wants to come back off. When the tape is removed, all that's left will be your beautiful design adhered to the phone case.

Repeat these steps with all the pieces of your design until the whole thing is in place. Then your case is ready to use. Just snap your phone inside and get ready to make a statement!

GALAXY PRINT T-SHIRT

WRITING TOOL: Cricut Infusible Ink™

SURFACE: Cotton or Cotton Blend T-Shirt

TECHNIQUES: Caps-Lock Print (page 18), Faux Calligraphy (page 12), Bounce Lettering (page 23), Banner (page 44), Infusible Ink

Graphic tees are a popular trend because they're a fun, comfortable way to show off your personality. When you have the right supplies, it's easy to create your own T-shirts that say anything you want. Whether you're looking to make several for yourself with different designs or mass-produce them to sell, there are several ways you can get your lettering onto a piece of clothing. If you don't own a cutting machine, your best option is to use fabric markers or fabric paint, like we did on our shoes (page 77). If you have a Cricut or Silhouette machine, you can use heat transfer vinyl, like we used for the Farmhouse-Style Throw Pillow we made on page 47. In this tutorial, we're going to look at one more option with a new product called Cricut Infusible Ink. Here's a step-by-step guide for using it to turn your hand lettered messages into fabulous and fashionable wearable art.

YOU'LL NEED

- Pencil and eraser
- Cricut or other electronic cutting machine
- Cutting machine mat
- Cricut Infusible Ink Transfer Sheets
- Cardstock
- Cotton or cotton blend T-shirt (a Cricut brand shirt is recommended)
- Cricut EasyPress 2 and mat or an iron and towel
- Lint roller
- Butcher paper (comes with the Cricut Infusible Ink Transfer Sheets)

1

2

STEP 1: **Plan and create your design.**

As always, we'll start with some practice and a pencil sketch on a piece of paper, like the blank page at the end of this tutorial (page 96). Since we will ultimately need to work with the image digitally, the easiest method for creating your lettering is to work in an app like Procreate on the iPad Pro. You can use the Apple Pencil and an assortment of brushes in the app to simulate all kinds of lettering markers. If you don't have this technology available, you can create your design using markers and paper, then photograph or scan your artwork to turn it into a digital file.

For my design, I chose the phrase "if you never try, you'll never know." First, letter "if you" in Caps-Lock Print (page 18), then write "never try" in Faux Calligraphy (page 12). Adding bounce to your lettering (page 23) will create a whimsical feel and take away the pressure of keeping your letters perfectly aligned. Below that, you'll draw a banner with the words "you'll never" inside of it in Caps-Lock Print. Finish off the design with the word "know" in Faux Calligraphy and a short horizontal line on either side of the word "try" to fill the empty space.

STEP 2: **Send your design to Cricut Design Space or other cutting machine software.**

If you created your file digitally, just save it as a PNG file with a transparent background, then upload it in your software and it will be ready to use. If you are working with a photo or a scanned image, you'll need to upload it, then use the tools in the software to remove the white background and anything else that is not part of your artwork.

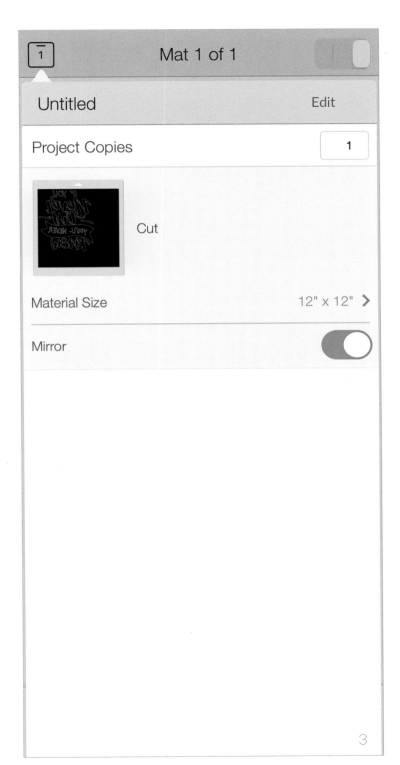

Untitled Edit

Project Copies 1

Cut

Material Size 12" x 12" ›

Mirror

3

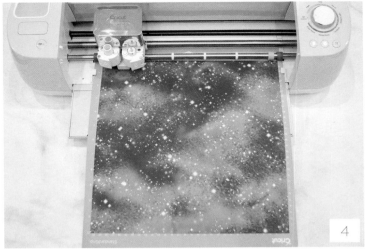

4

STEP 3: **Size and edit your design.**

The general guidelines for T-shirt images are that they should be a maximum of 12 x 12 inches (30 x 30 cm) on a man's shirt, 9 x 9 inches (23 x 23 cm) on a woman's shirt and 7 x 7 inches (18 x 18 cm) on a child's shirt. If in doubt, measure your shirt and see what a good size would be. Once you've sized your design properly, make sure to mirror it before you cut.

STEP 4: **Load your machine and cut the design from the Cricut Infusible Ink Transfer Sheet.**

Place your Cricut Infusible Ink Transfer Sheet on the machine mat with the printed side up. These ink sheets are available in a huge variety of solid colors, patterns and prints. I chose a galaxy print in purples and pinks. Follow the prompts in your software to send the design to the machine, then wait for it to cut. You'll want to turn the knob on the machine to Custom and set the material as Infusible Ink Transfer in the software. Aside from the gorgeous patterns available in the line of Cricut Infusible Ink Transfer Sheets, the best part about using them is that the ink actually fuses into the fibers of the shirt rather than sitting on top of the fabric like iron-on vinyl does. It creates a totally smooth professional finish that will never crack, wrinkle, peel or fade!

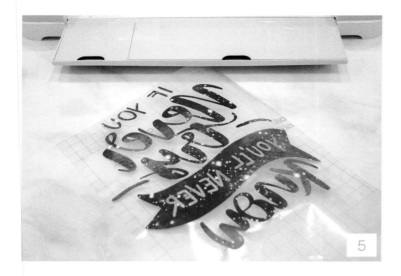

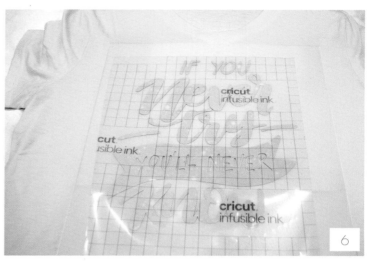

STEP 5: **Weed the design.**

Use your fingers or tools to remove everything that is not part of your design from the clear backing. Make sure to remove the centers from letters like "e," "a," "o" and "p."

STEP 6: **Prepare the T-shirt.**

Place cardstock inside your T-shirt to prevent the ink from bleeding through, then lay the shirt on top of a Cricut EasyPress 2 mat or a folded towel. Use a lint roller to remove any lint or dust from the fabric. Lay butcher paper on top of the shirt and preheat it with the Cricut EasyPress 2 set to 385°F (196°C) or an iron set to the highest cotton setting for 15 seconds.

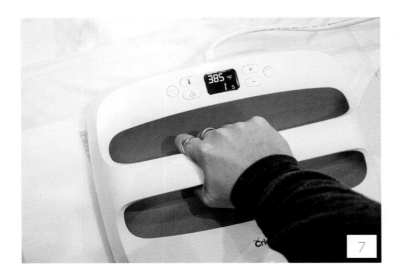

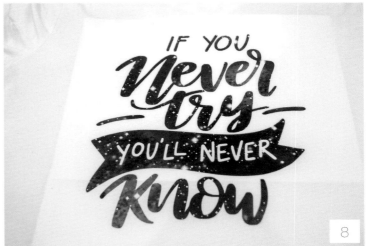

STEP 7: **Transfer the design to the shirt.**

Remove the butcher paper and place your design on the shirt with the ink side down, making sure you position it exactly where you want it to be. Place a new piece of butcher paper on top, then apply heat using the Cricut EasyPress 2 set at 385°F (196°C) or the hot iron for 15 seconds.

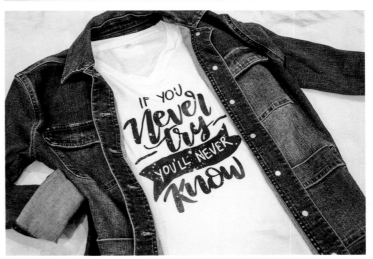

STEP 8: **Allow your shirt to cool, then remove the clear adhesive and what's left of the transfer blank.**

All of the color should have transferred to the shirt itself, leaving you with just paper pieces you can pick up and throw away.

Once finished, your shirt is machine washable and ready to wear!

PAINTED TOTE BAG

WRITING TOOL: Fabric Paint or Fabric Markers

SURFACE: Canvas Tote Bag

TECHNIQUES: Bubble Letters (page 72), Straight-Line Script (page 84), Caps-Lock Print (page 18), Dots and Diamonds (page 74), Highlights (page 81), Ampersands

I don't know about you, but I constantly find myself in need of a tote bag. Sometimes it's to carry my art supplies so I can letter on the go. Other times, it carries my iPad or Surface Pro so I can work on location at Starbucks. When my kids are not in school, it often serves as a method of transportation for games and my son's collection of *Minecraft* minifigures. No matter what happens to be on the inside of the bag, I like making sure that the outside is visually appealing. We're going to use our lettering, combined with fabric paint, to do just that as we create a humorous design featuring the phrase, "I like big books and I cannot lie." We'll be using a combination of fonts and embellishments you've already learned, as well as a lettered ampersand. Let's get started!

YOU'LL NEED

- Pencil and eraser
- Cardboard
- Canvas tote bag
- Ruler
- Painter's tape
- Chalk
- Fabric paint (I used Fabric Creations Soft Fabric Ink in black, white, Deep Teal, Grey Mist and African Violet) or paint markers
- Fine detail paintbrushes
- Iron
- Cloth pillowcase or other scrap fabric

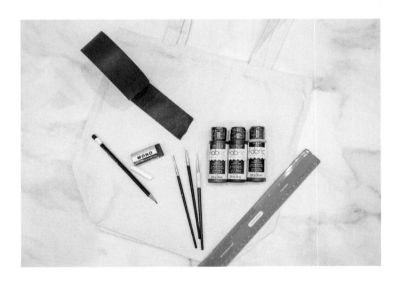

1

2

STEP 1: **Plan your design.**

As always, a big part of creating a successful project is making a plan, so you'll want to start by using a pencil to come up with exactly what you're going to letter. Remember, you can use the blank page at the end of the tutorial for practice (page 101). Feel free to use the design I'm about to share or to create something completely different. I am a huge book lover and former English teacher who often uses a tote bag to carry books. So, I thought it would be fun to letter the quote, "I like big books and I cannot lie." To emphasize "big books," you'll want to write those words larger than the others in the center of the design. Use Bubble Letters (page 72) for "big" and Faux Calligraphy (page 12) for "books." Draw semicircles above and below those words to shape the rest of the text, which looks great printed in Caps-Lock Print (page 18). To finish off the design, add dots and diamonds (page 74) in some of the empty spaces and draw an ampersand.

There are lots of ways you can draw ampersands; some look a lot like a capital script "E" while others are even more stylized. For this project, my ampersand is like a capital "E" with a swirling tail on the end. You can also make ampersands stand out by using the Faux Calligraphy technique to thicken some lines more than others. Check out the Alphabet Reference Guide on page 166 for examples of different ways you can draw this symbol, then choose your favorite and add it to the design.

STEP 2: **Prepare your tote bag and sketch the design.**

First, place a piece of cardboard inside your tote bag to keep the paint from bleeding through from the front to the back. The cardboard will also prevent the front and back layers of the bag from sticking together.

Next, use a ruler to find the center of the bag, then use painter's tape to mark the center. Mark guidelines for your lettering with chalk. You'll want to mark one line for "big" and another for "books."

Finally, use chalk to trace the top of the tape and make a guideline.

EXPRESS YOURSELF: A HAND LETTERING WORKBOOK FOR KIDS LATTA

HAND
Lettering
for

I LIKE
BIG
Books
&
I CANNOT LIE

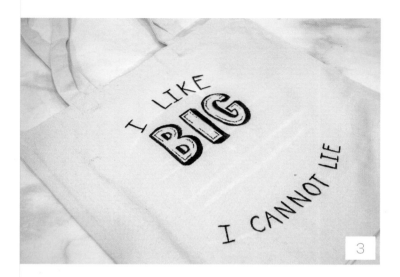

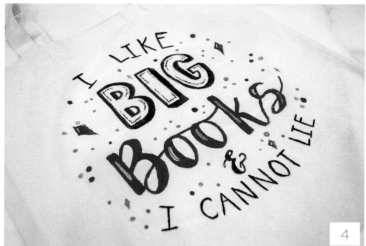

STEP 3: **Letter on your bag using a fine detail paintbrush and fabric paint.**

You could also use paint markers if you prefer, but I wanted to use the fabric paint so my bag would be machine washable. I used black paint for the words at the top and bottom of the design. Then I used Deep Teal and African Violet for the focal words.

STEP 4: **Add details such as highlights on the downstrokes of "books" and dots and diamonds embellishments.**

Make sure the word is dry before adding your highlights (page 81), and dots and diamonds (page 74) or the new paint will blend with your letter color instead of sitting on top.

PRO TIP: A great way to get round, evenly sized dots is to use the non-brush end of your paintbrushes. Just flip them over, tip the bottom in your paint and then touch it to your fabric. Voilà, a great-looking dot!

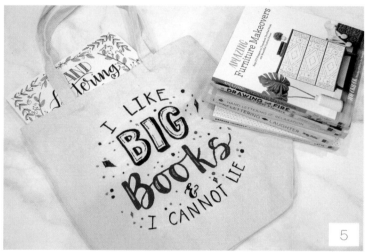

STEP 5: **Heat-set your fabric paint with an iron.**

Allow the fabric paint to dry overnight. Then heat an iron to the highest setting allowed for the decorated fabric (in this case, canvas). Position the fabric decorated side up and lay a clean cloth or pillowcase on top. Without using steam, press the iron to the painted area for 15 seconds, then lift the iron and move to another section. Continue until the entire design area has been heat-set.

Once your bag is heat-set, it can be washed, either on the gentle cycle in a machine or by hand in cold water. No matter how you use it, this bag will be both functional and stylish. In fact, I bet you'll find yourself wanting to create more.

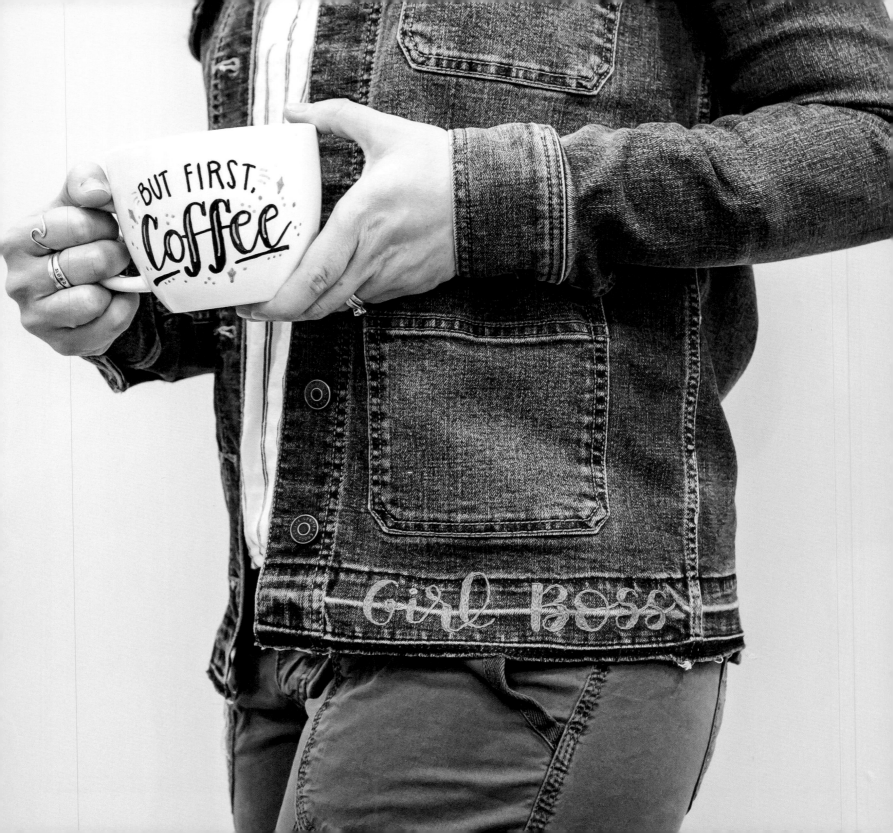

EMBROIDERED DENIM JACKET

WRITING TOOL: Needle and Thread

SURFACE: Denim Fabric

TECHNIQUES: Faux Calligraphy (page 12), Chain Stitch Embroidery

Fashion trends come and go, but there are certain pieces that have a timeless appeal. Ever since the 1950s, the denim jacket has been a classic, finding its way into wardrobes all over the world. Today, we're going to use our hand lettering skills to add a personal touch to this familiar classic. We're going to be using a new method this time, converting our design into something we create with a needle and thread. If you're not a pro at embroidery (and even if you've never attempted it before), don't worry. We're going to use very basic chain stiches to bring our Faux Calligraphy lettering to life, and I'm going to walk you through the process one step at a time. Grab your favorite jacket and let's get started!

YOU'LL NEED

- Pencil and eraser
- White chalk
- Denim jacket
- Scissors
- Embroidery floss (I used DMC brand in 964, Light Sea Green)
- Embroidery needle

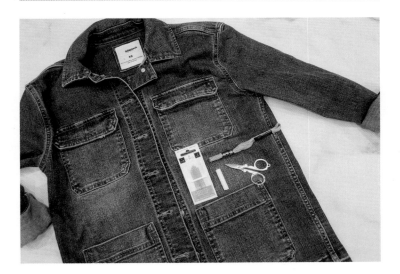

1

2

STEP 1: **Create your design plan.**

I wanted to keep things simple with a subtle statement, "girl boss," written along the bottom hem of the jacket in Faux Calligraphy (page 12). This way, the jacket is still very neutral and I can wear it with any outfit. However, if your own sense of style inspires you to create a large design on the back or elsewhere on the jacket, go for it! This is all about using your art to express who you are through fashion. As always, practice sketching your design with pencil first on the blank page at the end of this tutorial (page 106), so that you have a plan.

STEP 2: **Use chalk to sketch your design onto the denim.**

The white chalk will show up really well against the blue denim and any leftover marks will easily brush off when you're finished.

STEP 3: **Embroider the outlines of your letters using a chain stitch.**

Use scissors to cut the embroidery floss so that you have a piece about 25 inches (63.5 cm) long. Look closely and you'll notice that it's actually made up of six individual strands of floss. Take two of those strands and separate them from the other four. Thread those two through the eye of an embroidery needle and tie a knot at the bottom end. Starting from the interior side of your jacket, bring the needle up through the fabric at the top of your chalked "g." Make a small stitch by pushing the needle back through the fabric a little farther down your chalked letter and pulling the floss through until it's taut.

Bring the needle back up through the fabric roughly ½ inch (1 cm) away from your first stitch. Slide the needle under that first stitch and pull it through to the other side. Then put your needle back down into the same hole where you brought it up. This makes what we call a chain stitch. To continue, bring the needle up roughly ½ inch (1 cm) away from where you pushed it down, slide it under both sides of the previous chain stitch and put it back down in the same hole. Repeat this process all along the chalked lines and you will have outlined your letters with a chain stitch. Make sure to create the double lines on your downstrokes for the Faux Calligraphy technique.

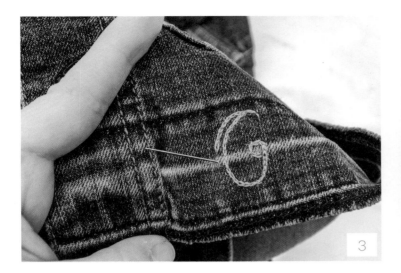

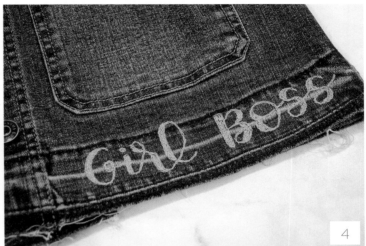

PRO TIP: When you run out of embroidery floss, secure it in the back by threading your needle under some existing stitches and tying a knot. Cut off any excess, then rethread your needle with two new strands of floss to continue.

STEP 4: **Fill the open spaces between your double lines with more chain stitches.**

Once your outline is complete, go back and use the chain stitch to fill the spaces between your double lines on the downstrokes. I was able to get two or three rows of chains between mine. For a different effect, you can do this step with a contrasting color of floss.

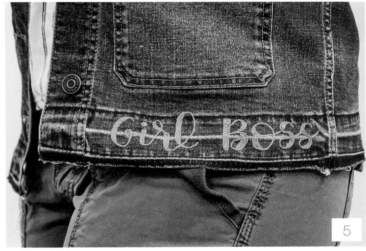

STEP 5: **Tie off your floss and brush off any remaining chalk.**

When your spaces are all filled in, tie off your floss on the back and cut off any excess. That's all there is to it; your jacket is ready to wear! You can wash it by hand or in the washing machine whenever necessary and your embroidery will stay intact. This technique can also be done on hats, jeans, bags, pillows, socks, aprons, decorative wall hangings and any other type of fabric project.

PRO TIP: Whenever possible, it's helpful to use an embroidery hoop to hold your fabric taut while stitching. Due to the placement of my words, I wasn't able to do this. But if you're stitching on the back of a jacket or another location where you're able to fit the fabric in a hoop, it makes the process a little easier, particularly when you're working with fabric that's thinner than denim.

GLITTERED BASEBALL CAP

WRITING TOOLS: Paint Markers, Glitter Fabric Paint

SURFACE: Cotton Baseball Cap

TECHNIQUES: Faux Calligraphy (page 12), Caps-Lock Print (page 18), Bounce Lettering (page 23), Paw Prints

I don't know about you, but I'm awfully thankful for my favorite hat on a bad hair day! Did you know you can create your own favorite headwear using your lettering and embellishing skills? It's easier than you think to turn a basic blank baseball cap into an accessory that conveys any message you want to share. The name of a favorite place or an event can create your own personalized souvenir or you can use a quote you love. Serious or silly, anything goes when you're illustrating your own apparel. You can find blank hats at your local craft store or online in a variety of colors. Choose one you like, then let's look at how to make it a one-of-a-kind accessory.

- Pencil and eraser

- Baseball cap

- White chalk

- Fine- or medium-tip acrylic paint markers, fabric paint markers or fabric paint (I used gold, white and pink)

- Fine detail paintbrushes

- Fabric Creations™ Fantasy Glitter™ fabric paint (optional; I used Meteor Shower, Supernova and Pixie Pink)

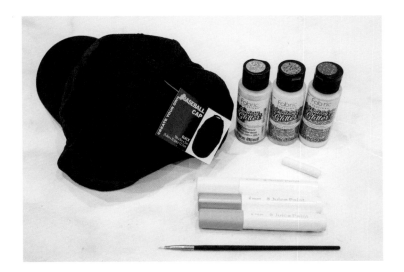

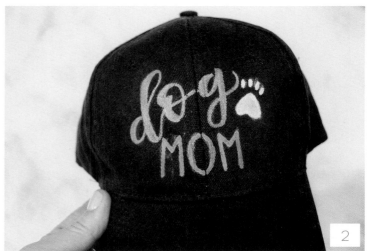

STEP 1: **Plan your design, then sketch it on the hat using chalk.**

First, feel free to practice the sample design with pencil on the blank page at the end of the tutorial (page 111). Then, when you feel ready, lightly sketch it on your baseball cap with chalk. This will easily brush off later, but for now it will mark exactly where you want your lettering to go. I decided to make my hat say "dog mom," since I'm crazy about my puppy! I sketched "dog" on a diagonal in script writing that I planned to turn into Faux Calligraphy (page 12). Below it, I wrote the word "mom" in Caps-Lock Print (page 18), making sure to center the "o" on the center seam of the hat. To balance out the design, I drew a little paw print in the upper-right corner. A paw print is a perfect, simple embellishment: just an upside-down heart with four little ovals over the top of it. I also turned the cap around and painted a tiny pink paw print on the adjustable strap.

STEP 2: **Letter on the hat using paint markers.**

If you're working with a white or light-colored hat, fabric markers or fabric paint will work too. I had trouble getting those supplies to show up on my black hat, so I used regular paint markers in gold, white and pink. Let your paint dry completely before moving on to the next step.

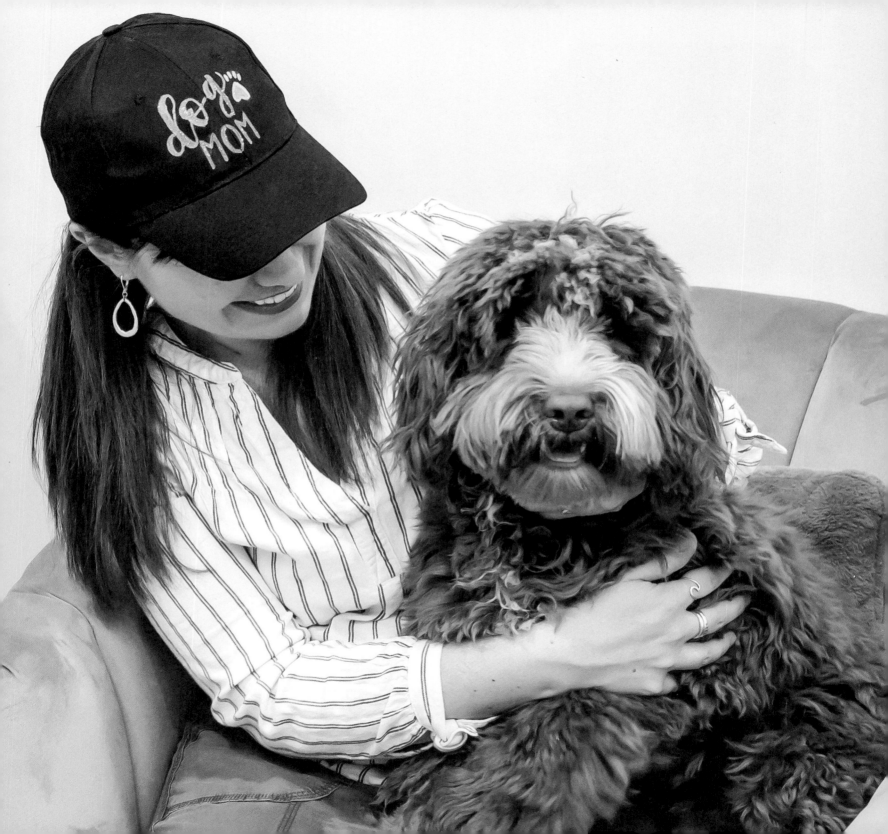

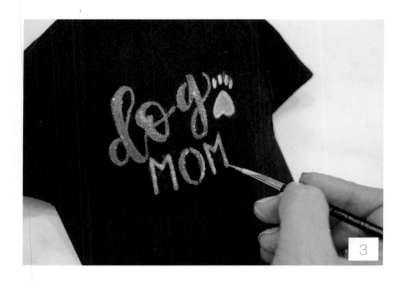

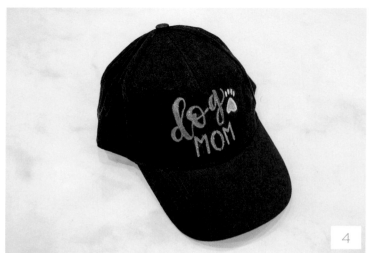

STEP 3: **Use a fine detail paintbrush to apply fabric glitter over top of your lettering.**

Make sure your painted lettering is fully dry before applying the fabric glitter. I chose several different colors of glitter to coordinate with the paint colors I used. I like using the fabric glitter because it's suspended in a clear solution that keeps the glitter exactly where you want it and prevents a big mess! Of course, this part is optional. If you're not a fan of sparkles, you don't have to use glitter at all.

STEP 4: **Gently brush away any remaining chalk.**

You should be able to do this with just your finger or a dry paper towel. Then all that's left will be your fabulous art! Be sure to wait until your paint and glitter are totally dry before doing this, though, so that nothing smears.

When the chalk is gone and everything is dry, your hat is ready to wear! Have fun using your own artwork to make a fashion statement. As always, feel free to customize it with any saying that means something to you.

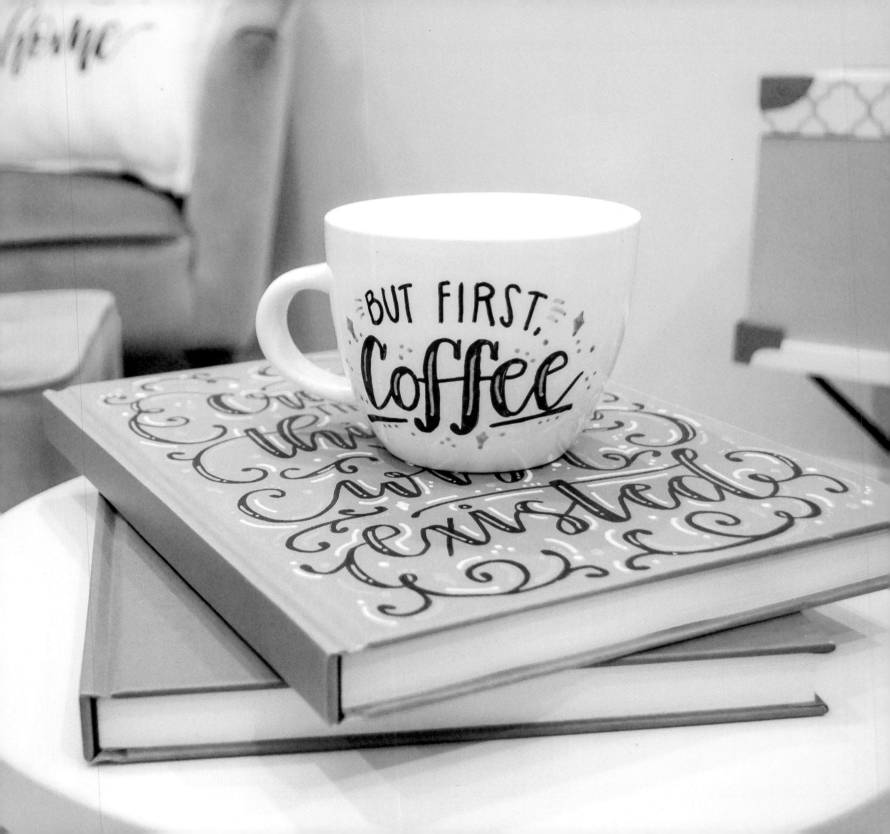

Gifts

Creating hand lettered projects for ourselves is certainly enjoyable, but it can be even more rewarding to put our skills to work creating a gift for someone else. There's always great joy to be found in giving, but perhaps never more so than when we've created the gift with our own hands. The final eight projects we'll be creating in this book will help you do that for the special people in your life. Of course, you can always create these for yourself too. Or make one to keep and one to give away!

We'll be learning to take a basic object like a coffee mug or a map and turn it into something full of personal meaning. There are a variety of different surfaces we'll be using, including paper, ceramic, wood and chipboard, and they can all be transformed by your lettered designs. As you recreate each project, you're always welcome to change the words or any other part to make it unique. If the person you're making the gift for has a favorite quote, feel free to use that in place of what I lettered. Whatever you do, these presents are sure to make the people in your life smile, because you're also giving the gifts of your time and talent.

HAND LETTERED COFFEE MUG

WRITING TOOLS: Ceramic Markers

SURFACE: Glass, Porcelain, Ceramic

TECHNIQUES: Caps-Lock Print (page 18), Straight-Line Script (page 84), Highlights (page 81), Dots and Diamonds (page 74)

YOU'LL NEED

- Pencil and eraser

- Coffee mug of any shape and size (I used a 16-oz [480-ml] mug)

- Rubbing alcohol and cotton swab or soft cloth

- Ceramic or porcelain paint markers (I used black, white, silver and gold)

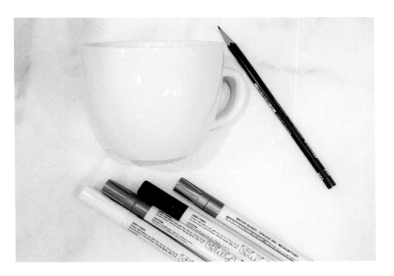

One of my favorite gifts to give and to receive is a coffee mug. I tend to collect drinkware from the various states and countries I visit, and I also can't resist a mug with a funny quote. Mugs, glasses and water bottles make great gift ideas because we all use them. And what could be better than giving a gift that's both useful and beautiful? When you add your hand lettered design to a piece of drinkware, it becomes a unique treasure that anyone on your gift list is sure to enjoy. For this project, we're going to use some special ceramic markers that will allow you to create personalized pieces that are washable and will stay intact even with daily use. You can also use the same technique and materials on wine glasses or other glass or ceramic drinkware.

1

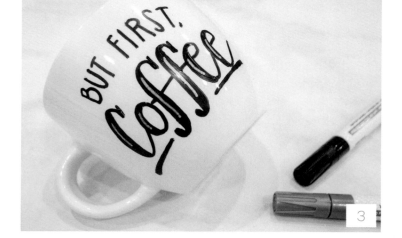

2

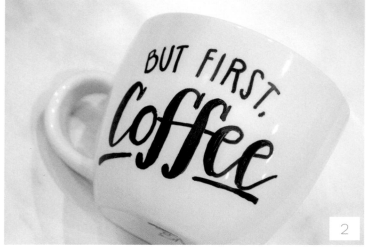

3

STEP 1: **Sketch a plan of your design with pencil and paper.**

Use the practice space on page 118 to sketch out your design. I thought it was only fitting to use a quote about coffee for my mug, so I decided to letter, "but first, coffee." Since "coffee" is the focal point of the saying, I decided to make it the largest part of the design. I chose to write it in Straight-Line Script (page 84) and to underline it for emphasis. I placed "but first," in an arch above the word "coffee," written in Caps-Lock Print (page 18). To embellish the design, I added highlights (page 81) to my downstrokes in "coffee," drew a few short, straight lines on either side of the arch and added a few dots and diamonds (page 74) in the empty spaces.

STEP 2: **Clean your mug, then letter your design with ceramic markers.**

Rubbing your mug with isopropyl alcohol will get rid of any fingerprints, dust or grease.

It's time to start lettering with your ceramic markers, which are specially designed to adhere to ceramic, porcelain and glass. They are nontoxic, but it's a good practice to make sure you leave ¼ inch (6 mm) of empty space below the rim before beginning your design so that your mouth doesn't actually come into contact with the lettered area. Since you can't sketch guidelines with pencil on drinkware, you'll have

to freehand this time, but don't worry. These markers are easily removable with a damp paper towel before they are heat-cured. If you make a mistake, just wash that area off and start over.

STEP 3: **Add highlights to the downstrokes of your letters in "coffee."**

I used a gold ceramic marker, but you could also use white or any other light color. Make sure your word is dry before adding these highlights (page 81) on top so that the colors don't smear or blend.

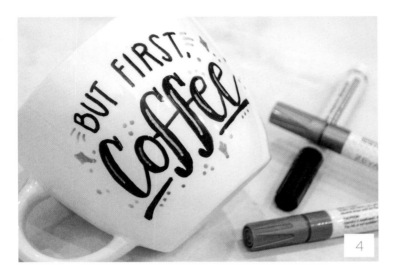

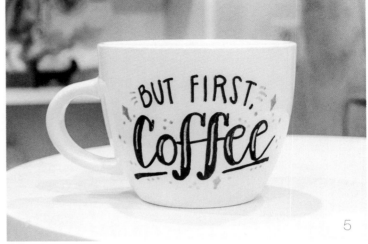

STEP 4: **Add dots and diamonds as embellishments.**

I chose to use a mixture of gold and silver for mine. I also added three short, horizontal silver lines on either side of the words "but first" to help draw the eye toward the words.

STEP 5: **Use heat to cure the ceramic marker.**

Let your project dry completely, preferably overnight or all day. Place the mug in a cool oven, then set the temperature to 400°F (204°C). Allow the oven to preheat while the mug is inside, then set a timer for 30 minutes once the preheating is complete. After 30 minutes, turn off the heat and allow the project to stay in the oven until it has completely cooled.

PRO TIP: It's very important to insert and remove the mug when the oven is cool; otherwise, the extreme temperature change can cause the ceramic or glass to crack.

Once the mug has cooled and you've removed it from the oven, it's ready to be used. I recommend gently washing the drinkware by hand rather than placing it in a dishwasher.

Not only is drinkware fun to make for yourself, it's also a great gift idea for the coffee and tea lovers in your life. You can find very inexpensive mugs at thrift stores and yard sales or at stores like Target, Dollar Tree and Walmart. Make them totally personal by adding a meaningful name or quote. For an extra special present, place something inside, like candy, homemade cookies or packages of coffee, tea or hot cocoa. The ceramic marker technique we learned works great for mugs and glassware of all kinds. Another option is to use permanent adhesive vinyl like we did to decorate the Custom Phone Case on page 83. Permanent vinyl can be used on plastic and metal drinkware as well as glass.

DECORATIVE FLOWERPOT

WRITING TOOLS: Extra-Fine Tip Paint Markers

SURFACE: Ceramic or Terra-Cotta

TECHNIQUES: Faux Calligraphy (page 12), Bounce Lettering (page 23), Caps-Lock Print (page 18), Dots and Diamonds (page 74), Highlights (page 81), Shadow Lines

Flowers and plants make great gifts because they bring color and cheer into any space. Even if you're someone like me who tends to have a black thumb rather than a green one, a plant is a thoughtful and welcome gift. This project gives us an opportunity to give not just a plant but a totally unique, personalized flowerpot as well. You can start with a basic terra-cotta pot in any size and shape then paint it a solid color before lettering, or you can opt for a ceramic one that's already colored. I chose a simple white flowerpot from my local craft store that was the perfect size to hold a small succulent. Then, as a nod to those of us who struggle to keep our plants alive, I chose the phrase, "I will survive"!

- Pencil and eraser

- Flowerpot

- Oil-based paint markers with a fine- or extra-fine tip (I used black, gold and white)

STEP 1: **Plan your design, then lightly sketch it with pencil on the pot.**

Sketch the layout and word positions you want to use on a piece of paper like the page at the end of this tutorial (page 123). Feel free to use the same design I did or to come up with your own variation. To make light of my innate ability to kill plants, I chose the phrase, "I will survive." Since I wanted to emphasize the word "survive," I decided to write it in large Faux Calligraphy (page 12) letters while keeping the other words in a simple Caps-Lock Print (page 18).

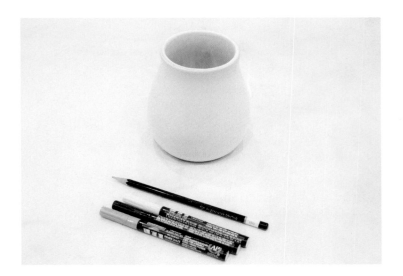

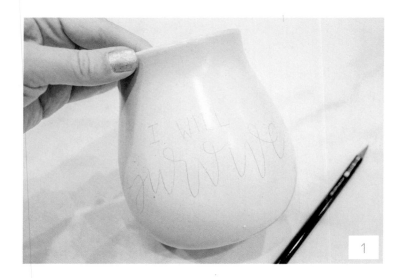

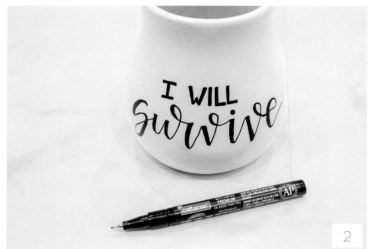

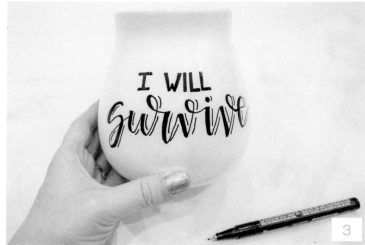

Once you're happy with your design, lightly sketch it on the pot with pencil. (You'll want to test your pencil on the bottom of the pot to make sure it erases cleanly.) It's almost impossible to draw straight guidelines on a curved surface, but using the bounce lettering technique (page 23) will help keep things looking balanced.

STEP 2: **Trace your lettering with the paint markers.**

I used extra-fine tip markers on my project, so I had the option to make very thin lines and accents.

STEP 3: **Add shadow lines to the right of each letter in "survive."**

For this step, I imagined where I'd draw a shadow if the light source were in the upper-left corner of the page. Then I drew a short line in each of those places.

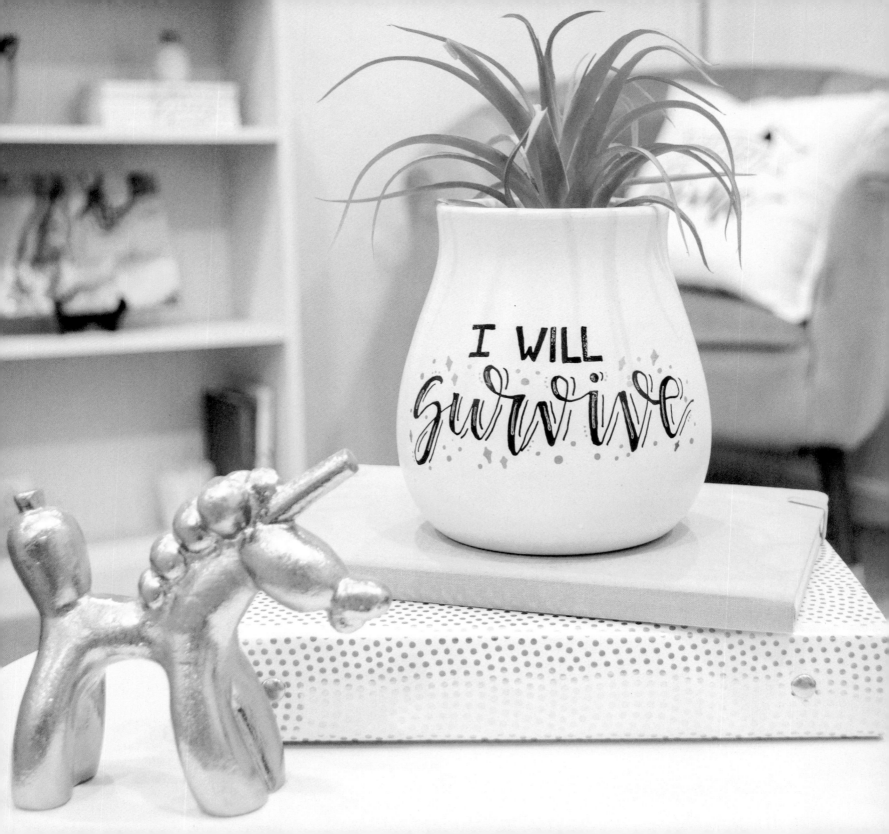

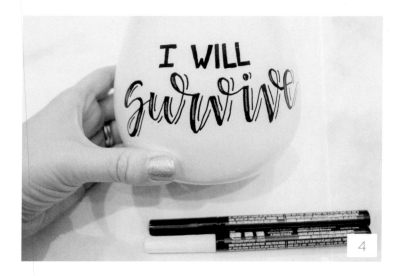

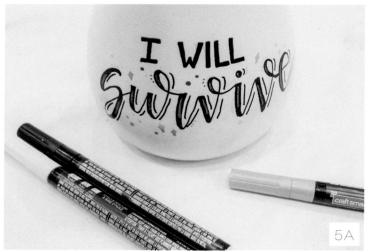

STEP 4: **Use a white paint marker to add highlights on the downstrokes of each Faux Calligraphy letter.**

Make sure your lettering is dry before adding your highlights.

STEP 5: **Add some dot and diamond embellishments in gold.**

I kept my dots and diamonds close to the word "survive" to help emphasize it, but you can place them anywhere you like. Feel free to cover the whole pot with them or just balance them around the text like I did.

Once you've completed your design, let the paint dry and cure—then the flower pot is ready to use! (Check your markers' packaging for details about curing times.)

See? Creating a decorative flowerpot isn't difficult at all—the hard part (at least for me) is figuring out how to keep the plant alive and thriving! Luckily, these flowerpots are still adorable even if the plant inside is made of plastic.

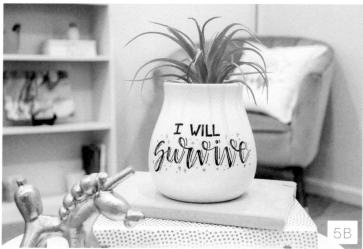

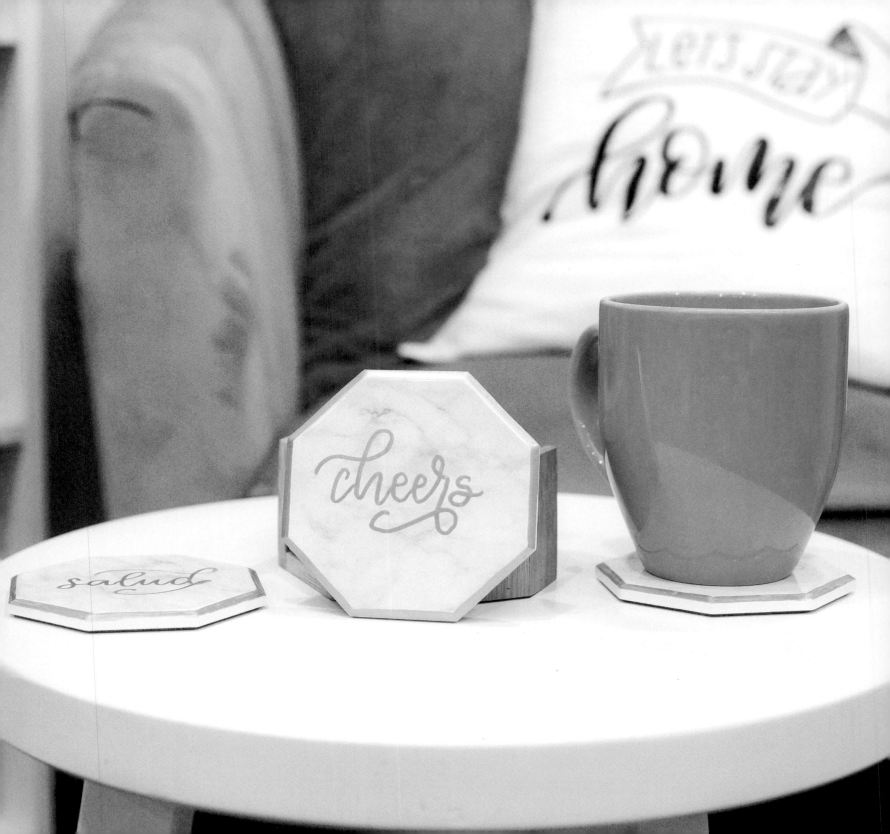

ELEGANT MARBLE COASTERS

WRITING TOOLS: Ceramic Markers

SURFACE: Marble or Ceramic Coasters

TECHNIQUES: Simple Script, Bounce Lettering (page 23)

For anyone who loves to entertain, coasters are the perfect gift. We all use them, and they're a great way to mix style with function. When it comes to choosing the coasters themselves, you'll have lots of options for shapes and sizes. I chose an octagon-shaped set, because I thought they were visually more interesting than round ones. However, you can choose whatever style you like best. To personalize them, a last name or a monogram can be a thoughtful touch, or you can go for something simple, like "cheers." We'll be writing on these coasters using the ceramic marker technique we used on the Hand Lettered Coffee Mug on page 115, but we'll be keeping things very minimal and elegant, using Simple Script and a basic gold outline. Let's take a look at how easy these are to create.

YOU'LL NEED

- Pencil and eraser
- Rubbing alcohol
- Marble or ceramic coasters
- Ceramic or porcelain markers (I used gold)
- Painter's tape (optional)

1

2A

STEP 1: **Plan your design.**

Although we're keeping things minimal, planning is still the best policy! Practice writing your words and look for letters you could flourish. I chose to use the word "cheers" on half of my coasters and the Spanish toast "salud" on the others. The lowercase "h" and "d" lend themselves to flourishing at the top, while "r" is a letter you can flourish on the bottom. To create my flourishes in the word "cheers," I simply started the stem of my "h" out toward the left of my word rather than connecting it to the "c" right before it. For the "r," after my downstroke, I drew a loop and carried it backward to underline the word. In "salud," both of my flourishes are on the "d," one at the top of the stem and one at the bottom. Use a pencil to play around with your words in the practice area (page 128) to see just how you want them to look before you begin working with the ceramic markers. Try different kinds of flourishes and see what you like best!

STEP 2: **Clean and dry your coasters, then write your words in the center.**

I recommend using rubbing alcohol to clean the coasters in order to make sure any fingerprints, dust or grease are removed from the surface before you begin. These things can prevent the markers from adhering properly.

I chose to use a gold ceramic marker because I thought it looked particularly elegant on the white marble. Writing in Simple Script is easy; it's just a pretty cursive font. You'll form your letters the same way you would for Faux Calligraphy (page 12), but don't go back and thicken any of the lines. Instead, keep all of the lines an even thickness. You will, however, want to use bounce lettering (page 23) and allow the letters to drift above and below the baseline so that you don't have to worry about keeping everything perfectly straight. See page 165 for the full alphabet written in Simple Script so that you can practice it, as well as reference it while you work.

Don't forget to add those flourishes you practiced! Repeat this step until all of your coasters have words in the center.

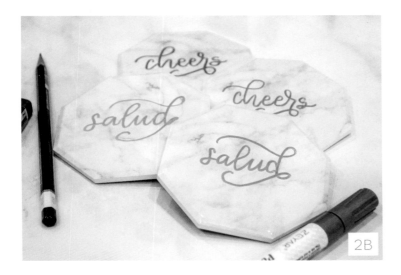

2B

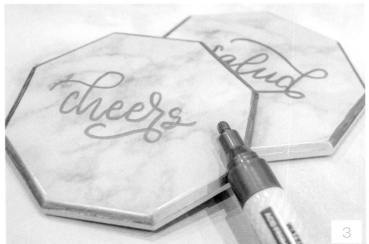

3

PRO TIP: If you make a mistake, it's no problem. Until the coaster has been cured in the oven, you can easily wipe off the marker with a wet cloth.

STEP 3: **Color the edges of the coaster with your gold ceramic marker.**

The particular coasters I used have nice beveled edges that made this very easy to do. If yours don't, you can tape off an edge section using painter's tape to help you get nice straight lines.

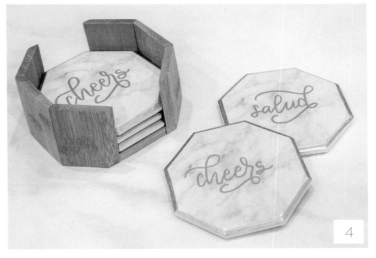

4

STEP 4: **Use heat to cure the paint.**

Place your coasters on a baking sheet and put them in a cool oven. Next, preheat the oven to 400°F (204°C). Allow the coasters to bake for 30 minutes after the oven is preheated, then turn off the heat. The coasters should stay in the oven until it has cooled down completely, then they're ready for you to remove and use.

PRO TIP: Placing the coasters in a hot oven or removing them before the oven has cooled can cause the ceramic or marble to crack. Instead, we want to allow them to heat and cool gradually.

Once your coasters are cured, they're ready to be shared with a friend! If they came with a holder like mine did, you can place them inside. If not, you could tie them together with ribbon or twine and add a gift tag (a hand lettered tag like the Gold Glitter Gift Tags found on page 151 would be perfect). They make a beautiful and useful present for family, friends, neighbors or anyone else on your list.

EMBELLISHED HARDCOVER SKETCHBOOK

WRITING TOOLS: Oil-Based Paint Markers or Permanent Markers

SURFACE: Cloth Hardcover Book

TECHNIQUES: Faux Calligraphy (page 12), Caps-Lock Print (page 18), Dots and Diamonds (page 74), Highlights (page 81), Bounce Lettering (page 23), Shadow Lines (page 120), Flourishes and Swirls

If you have an artist or a writer in your life, imagine how special it would be to receive a sketchbook or journal that's personalized with custom artwork on the cover! With a few paint markers, or even regular permanent markers, you can create a one-of-a-kind cover that inspires your recipient to fill the pages with even more creativity. You can keep things simple, or you can go all out and fill the entire cover with your lettered design. We'll be looking at two different covers that start out with the same basic design idea. Choose the one that appeals most to you, or create something that's all your own!

- Pencil and eraser

- Hardcover sketchbook or journal

- Oil-based paint markers or permanent markers (I used black, gold, silver and white)

1

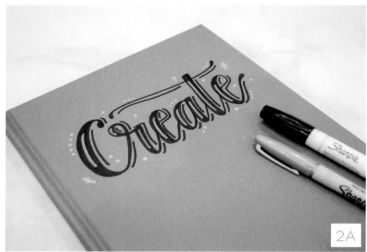

2A

STEP 1: **Plan your design.**

Both of my designs begin with the word "create" written in Faux Calligraphy (page 12). One is simply the stand-alone word, embellished with highlights (page 81) and dots and diamonds (page 74). The other extends the phrase in Faux Calligraphy and Caps-Lock Print (page 18), and has swirls and flourishes that take up most of the space on the front cover. The page at the end of this tutorial (page 134) is a great place to experiment to see which design you like best. Play around with flourishes, which are nothing more than loops and swirls extending from the letters or standing on their own.

One easy way to make a flourish is to start with a swirl toward the left of a letter before forming the rest of the shape. Or you can write a letter then continue it outward to the right with a loop or a swirl. In the sample design, we will be doing this for the first and last letter of each word. The lines used to cross a "t" are also great opportunities for adding loops and swirls. Sometimes you can even connect your letters together; for example, we'll use the line that crosses the "t" to form the beginning of the "d" in the word "existed."

STEP 2: **Sketch your design on the cover, then trace and add embellishments.**

Remember to do your initial sketch lightly with pencil so any remaining lines are easy to erase. Then go over your sketch with paint markers or permanent markers.

If you're going for the simple design, add a few highlights (page 81) and shadow lines (page 120), then place some dots and diamonds (page 74) around your word, leaving the majority of the cover blank (Image 2A).

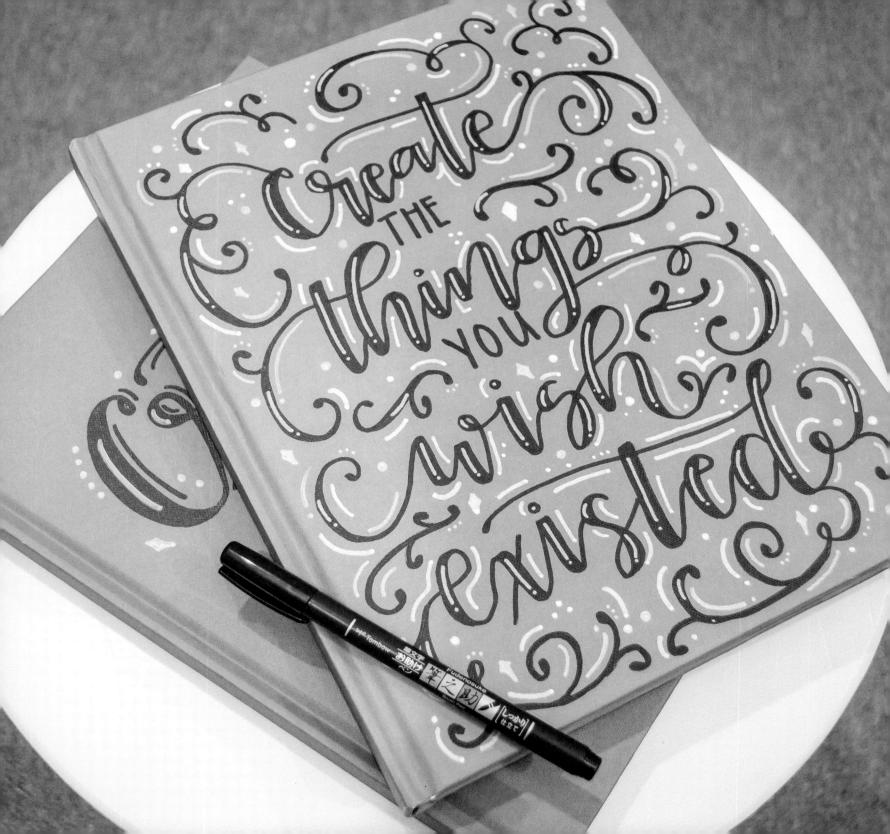

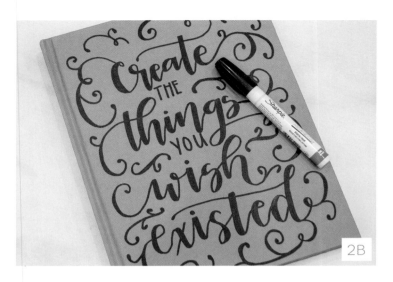

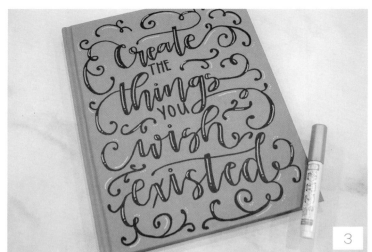

If you're going for the larger design, you'll want to start by adding the flourishes to your letters (Image 2B). Try to add one to the first and last letter of each word if possible, as well as any other letters that particularly lend themselves to extra loops and lines. The letter "t" is great for embellishing, and so are letters with ascenders or descenders, like "d," "h," "g" and "y."

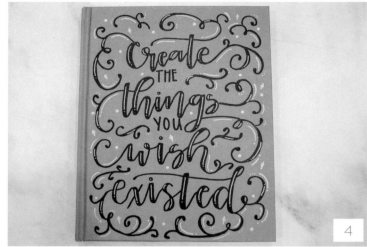

STEP 3: **Add gold accents.**

After completing all of the lettering, flourishes and swirls with the black marker, I used a gold marker to add highlight and shadow lines as well as some dots and diamonds (page 74).

STEP 4: **Add silver accents.**

I repeated the same process, this time using a silver marker to incorporate two metallic colors for visual variety.

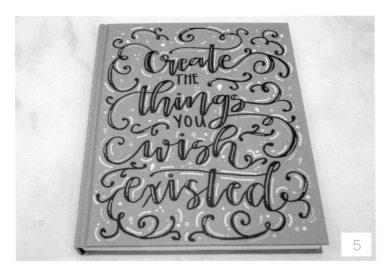

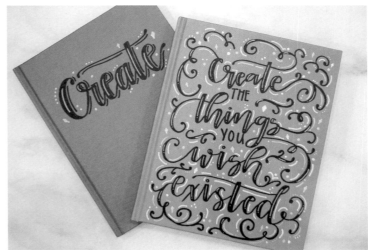

STEP 5: **Add white accents.**

Finally, I added white embellishments, like dots, diamonds and short curving lines to fill any remaining open spaces.

Your finished project, no matter which design you choose, should make the cover a lot more interesting than it originally was! Plus, you can always personalize it even more by adding a name or initials. This is sure to be a treasured gift that can be used for drawing, lettering, journaling, making lists, organizing and more. I suggest buying a few books to decorate, because you're going to want to keep at least one for yourself, too!

CUSTOMIZED CLIPBOARD

WRITING TOOLS: Paint Markers

SURFACE: Chipboard

TECHNIQUES: Elongated Script (page 38), Bubble Letters (page 72), Caps-Lock Print (page 18), Banners (page 44), Florals (page 33), Shaped Designs

Clipboards aren't just for camp counselors and doctors; they're really handy organization tools for just about anyone. A hand lettered design is the perfect way to use the blank space on the back of this everyday object and turn it into something fabulous. Clipboards are available in a huge variety of colors as well as different materials, including plastic, metal and the standard brown chipboard. We'll be working with the standard brown clipboard version for this sample project, but the process for lettering on any of the other varieties is essentially the same. Our method this time will be to use paint markers, but you could also use permanent vinyl, like we did for the Custom Phone Case on page 83. We'll be using a design that makes use of shaped lettering and vibrant colors for an eye-catching project!

YOU'LL NEED

- Pencil and eraser
- Clipboard
- Ruler
- Paint markers

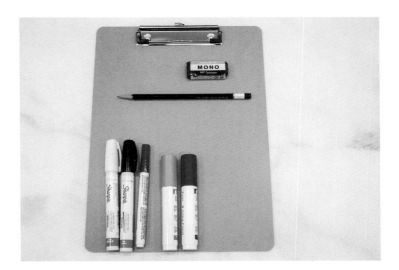

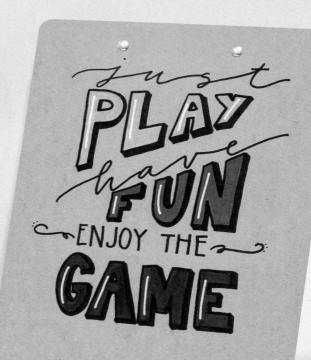

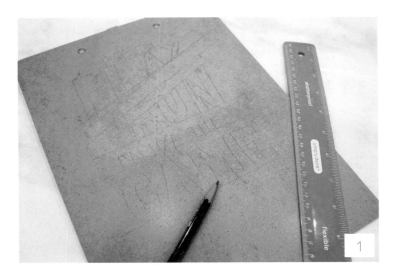

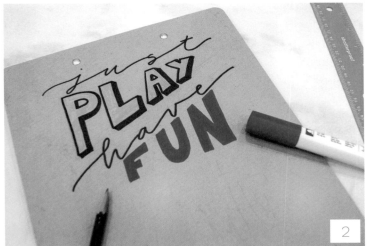

STEP 1: **Plan your design, then pencil guidelines on your clipboard.**

A clipboard is a perfect gift for a coach, athlete or big sports fan, so I decided to go with a design that would be meaningful to someone no matter what sport happens to be his or her specialty. Michael Jordan's quote—"Just play. Have fun. Enjoy the game."—is a great reminder that win or lose, any practice or game can be a great time. To create visual interest and draw the eye to certain words, we're going to be using shaped text. Rather than just writing on straight lines, you can draw various shapes as part of your composition and fit your words to them. For this design, you'll start by sketching two triangles and fitting the words "play" and "fun" inside. Use Bubble Letters (page 72) for these words, which, along with the shaping, will help them stand out. Next, add "just" and "have" in Elongated Script (page 38) above the triangles, then write "enjoy the" in Caps-Lock Print (page 18) underneath. Finally, use Bubble Letters again for the word "game." Small swirls on either side of "enjoy the" add the perfect finishing touch.

A good way to keep your design centered is to use a ruler to locate the middle of the clipboard first and mark it in pencil, then draw everything else. You'll also want to add a pencil line to section off a portion of the bottom of the clipboard for color blocking.

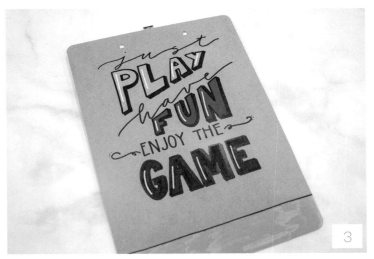

STEP 2: **Trace your design using paint markers.**

To really make the words pop, fill the Bubble Letters with color. Draw the letters in various colors first and color them in, then outline them in black and add the drop shadows. Once the lettering is dry, add white highlights (page 81) to the Bubble Letters.

STEP 3: **Erase any remaining pencil lines.**

Make sure your project is totally dry first, so that the paint doesn't smear.

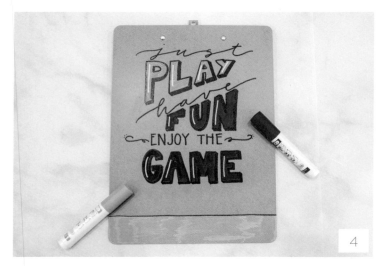

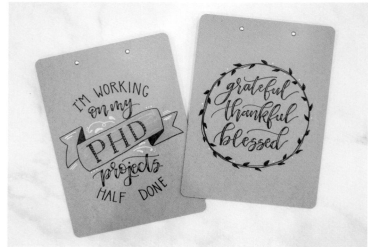

STEP 4: **Use a paint marker to fill the area below your bottom pencil line.**

This will add a fun pop of color! It's also a great area to letter in the name of the coach or sports fan to whom you're giving the clipboard. Separate the colored area from the rest of the board with a black line. This step can also be done with acrylic or multisurface paint and a brush if you prefer that method to the paint marker.

If you don't happen to have any coaches in your life, this is also a great gift idea for an artist, a teacher or just someone who loves (or needs!) organization. By changing the quote, it can become totally personalized for any recipient, and it's a very inexpensive, quick-to-make present. My clipboard cost fewer than three dollars and I already had the other supplies on hand. Above are two other examples of what you can create: One is simply a quote in Faux Calligraphy (page 12) surrounded by a wreath like the one we drew on our Family Name Floral Canvas (page 31) and our Stripes and Vines Front Door Sign (page 36). The other uses Faux Calligraphy, Caps-Lock Print (page 18) and a banner (page 44) to convey a funny message most of us can probably relate to about unfinished projects!

TEACHER CLASSROOM SIGNS

WRITING TOOLS: Paint Markers or Chalk Markers

SURFACE: Coated Wood

TECHNIQUES: Faux Calligraphy (page 12), Bubble Letters (page 72), Bounce Lettering (page 23), Sports Balls and Music Notes

Every year, I find myself in need of gifts for my boys' teachers. Between Christmas, Teacher Appreciation Week and the end of school, I'm constantly trying to think of small tokens to show our gratitude. One of the things I love to do is create a personalized classroom sign for each teacher that features his or her name and a special illustration. Sometimes I use a border or drawing that represents the teacher's subject matter, while other times, the boys will tell me things they know about their teachers on a personal level, like a fondness for *Harry Potter*, dogs or a certain sports team. These signs are incredibly inexpensive to make, but the personalization turns them into treasured gifts. It's so much fun to walk the hallways of the boys' school and see the signs on display outside the classrooms of their current and former teachers. These signs could also easily be adapted for hairstylists, doctors, dentists, administrative assistants, day-care providers or anyone with an office or cubicle.

- Pencil and eraser
- Mini chalkboards
- Chalk or painter's tape
- Fine- or medium-tip paint markers or chalk markers in white and various colors

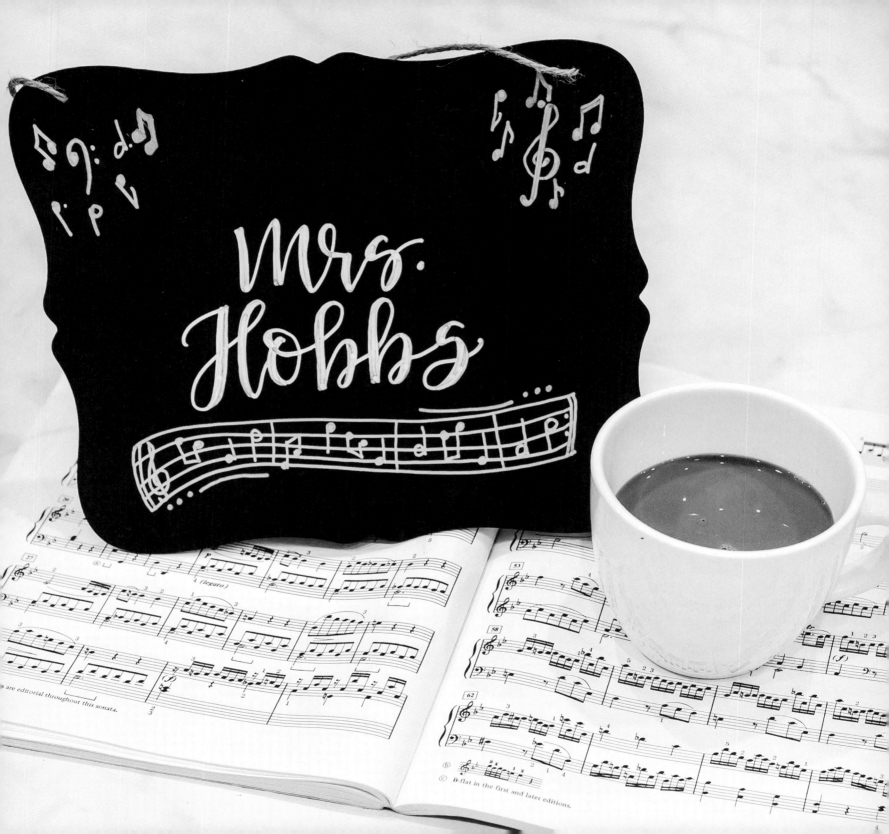

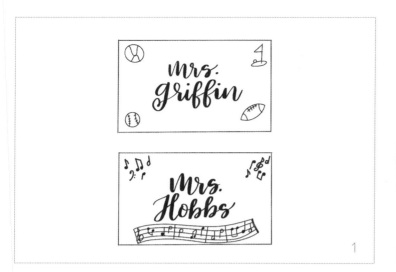

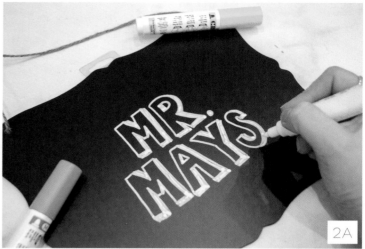

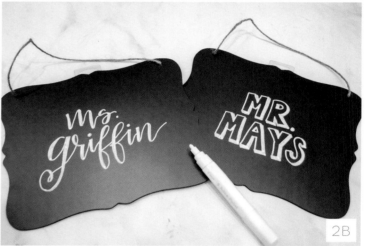

STEP 1: **Plan your designs.**

Think about each teacher's subject or interests and come up with a plan for how you'd like to decorate the sign. It's much better to play around with ideas with paper and pencil, when you can erase and change them, than to experiment on your surface with paint markers. The blank page at the end of this tutorial (page 145) is the perfect place to do your drafting. Start by choosing your favorite font for writing the teacher's name, then think about what kind of border or corner illustrations would best represent that teacher.

STEP 2: **Mark the center of the board, then write the teacher's name.**

I like using bounce lettering (page 23) so that it's okay if my letters aren't totally straight, but it's still nice to know where the center of the board is. That will help you position the teacher's name correctly. You can mark the center with chalk or with a piece of painter's tape that can easily be removed. I like to start by writing the center letters first, then move outward to each side of the sign.

Use your paint markers to complete the lettering in your choice of font, being careful not to place your hand in the wet paint as you work (Image 2A).

Personally, I like to use Faux Calligraphy (page 12) and Bubble Letters (page 72). Caps-Lock Print (page 18) and Faux Calligraphy Print (page 44) are great choices, too (Image 2B).

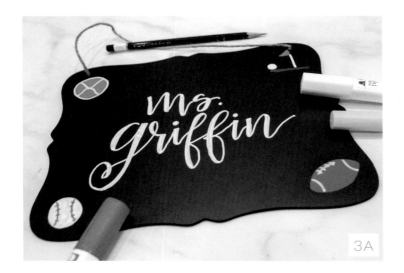

3A

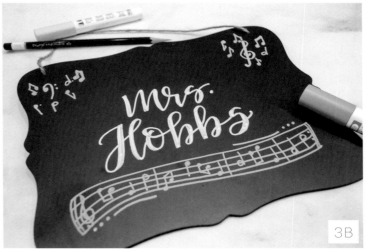

3B

STEP 3: **Illustrate the sign in the corners and around the edges.**

Each sign will be as unique as the person who is going to receive it. For my sons' physical education teachers, I chose to draw a variety of sports balls: a basketball, a baseball, a football and a golf ball with a flag. These are very simple to draw, because for most sports balls, all you have to do is make a circle, then add color and small details to distinguish what type of ball it is. A golf flag is simply a line with a colored triangle at the top (Image 3A).

For the music teacher, I drew some music notes and a treble and bass clef in the top corners. Like the sports balls, music notes are nothing more than basic shapes. Draw a small circle, then attach a line to one side. A line on the right side should extend above the note, and a line on the left side extends below it. You can color in the note (a quarter note), or leave it open (a half note). Across the bottom, I added a musical staff, just five lines with notes drawn on the lines and in the spaces (Image 3B).

Here are some ideas for teachers of other subjects (Image 3C):

MATH

- Include symbols like "+," "-," "x," "/," "<" and ">."

- Write out as many decimal places as you can of the number pi around the border.

- Make up math problems or equations.

- Draw a ruler, protractor, calculator or compass.

- Draw geometric shapes.

SCIENCE

- Draw test tubes and beakers.

- Draw strands of DNA (curving lines that intersect with little horizontal lines between).

- Include a diagram of an atom or molecule.

- Draw some goggles.

- Draw pictures of plants or animals.

- Draw a magnifying glass.

3C

3D

ENGLISH, READING OR LANGUAGE ARTS

- Draw an open book.

- Draw a stack of books.

- Draw a pencil, pen or quill.

- Letter a famous quote or authors' names around the border of the sign.

SOCIAL STUDIES, HISTORY AND GEOGRAPHY

- Draw a globe.

- Draw a map.

- Draw a stack of books.

FOREIGN LANGUAGE

- Draw a map or the shape of a country.

- Draw food, national symbols or the flag of a country.

ART

- Draw a paintbrush and palette.

These are just some ideas to get you started. Plus, think about including anything you know about the teacher's hobbies or interests outside of school. For example, my son's math teacher last year was a huge fan of *Harry Potter*, so we customized her sign with symbols from the series. This year, their math teacher loves dogs, so we drew paw prints and dog bones.

No matter how you illustrate the sign, it's sure to be a personal gift that will be appreciated and used for years to come.

BRUSH SCRIPT MAP ART

WRITING TOOL: Brush Pen or Marker

SURFACE: Paper Map

TECHNIQUES: Caps-Lock Print (page 18), Brush Script

Each of us has a list of places that are meaningful to us. Our hometowns, college towns, favorite vacation spots— all of these locations hold special places in our hearts. When someone we care about moves to a new home or experiences a significant life event, a piece of map art can be a thoughtful gift. In fact, there's no wrong time to give the gift of a personalized map. You can easily take it to the next level by adding a personal hand lettered message, like our sample design for this project, "home is where the heart is." You could also write, "our favorite place," "home is wherever I'm with you" or an important date. This hand lettered map art can be sized to display on a wall, on a desk (like ours) or anywhere in between. No matter what you choose, it's sure to be an unforgettable present.

- Picture frame in any size (mine is 4" x 6" [10 x 15 cm])

- Printed map to fit the frame

- Scissors or paper cutter

- Brush pen/marker (I used a Tombow Fudenosuke Soft Tip Brush Pen)

- Monoline drawing pen (I used a Tombow MONO Drawing Pen)

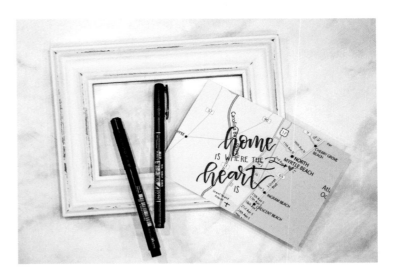

1

home
IS WHERE THE
heart
IS

2

STEP 1: **Print and trim your map to fit the frame.**

Choose your recipient's favorite place, then print or buy a map of it. I found that doing an internet search for our vacation spot in North Myrtle Beach gave me numerous maps to choose from. You can use any style and size map you like: a whole state, a city or a close-up of a town. Once you have your map, use scissors or a paper cutter to trim it to fit inside your frame.

STEP 2: **Use a combination of Caps-Lock Print (page 18) and Brush Script to create your design.**

I decided on the phrase "home is where the heart is." You could also letter the name of the location, a significant date or anything else that's related to the special place. I wrote on a diagonal so I didn't have to worry about keeping my lettering perfectly aligned.

For our other projects, we've been writing in Faux Calligraphy (page 12) to get the look of Brush Script, because typical brush pens aren't ideal for the variety of surfaces we're using. However, this time we're writing on paper, so we can actually use the "real" brush lettering technique and tools! Like Faux Calligraphy, Brush Script is

thick on the downstrokes and thin on all the others. The difference is how we achieve that effect. For Brush Script, we use a brush pen and control the thickness of our lines by applying and removing pressure as we write.

While you can use any brush pen, I highly recommend the Tombow Fudenosuke. It is easy to control and a great tool for beginners and advanced artists alike. This technique will not work with any other type of pen or marker. Once you have a brush pen, it's time to start learning how to make different kinds of strokes.

Every time you make a downstroke, you'll apply pressure to the pen, causing it to make a thick, dark line. Don't be afraid of damaging the pen tip; it's made to respond to pressure. Practice making a series of downstrokes on the blank page at the end of the tutorial (page 150) or on a separate scratch paper. Move your pen from top to bottom and you should have bold, thick lines. In contrast, when your pen changes direction to go any way besides down, release that pressure and you'll get a much thinner line instead. Try making a series of upstrokes next to the downstrokes you just wrote. They should be noticeably lighter and thinner. If you're new to this technique, check out the reference guide on page 164 to see some more practice drills you can do and a sample alphabet to get you started. Remember, you can use the blank space at the end of this tutorial (page 150) to practice the technique.

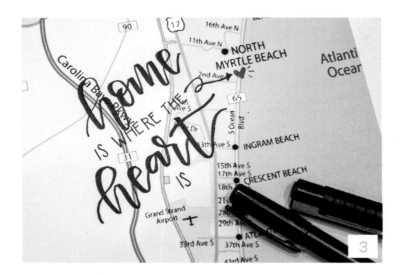

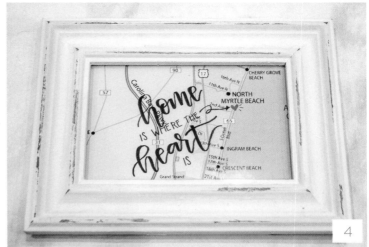

STEP 3: **Letter the design on your map with a brush pen.**

Do your best, but don't worry about perfection! If you make a mistake or aren't happy with the outcome, it's easy to print a new map and try again.

STEP 4: **Draw a heart and arrow with the monoline drawing pen to indicate your special place on the map.**

Use a red marker to draw a heart, then draw a black arrow pointing to it. You can also draw a few short lines extending from the side of the heart to call attention to it.

All that's left to do is pop your lettered map in a frame. I went with a frame I bought at Walmart that I painted and distressed using the techniques we used on the Chalk-Painted Furniture Upcycle (page 55). You can use any color, size and style of frame that will be a good fit with your recipient's home décor.

This project takes very little time to complete and is incredibly inexpensive. In fact, the only real cost is the price of the photo frame. Despite how simple it is, it makes a thoughtful and personal gift that anyone in your life is sure to treasure.

PRO TIP: You can find a great deal on photo frames at thrift stores and yard sales, and sometimes they're even unused!

GOLD GLITTER GIFT TAGS

WRITING TOOLS: Embossing Pen and Powder

SURFACE: Cardstock

TECHNIQUES: Brush Script (page 148), Bounce Lettering (page 23), Embossing

As you've seen, hand lettered projects can make meaningful, personal and inexpensive gifts. But that's not all! Lettering can play a role in our gift packaging as well. Now that you know how to create some gift-able project ideas, let's take a look at how to create some simple but gorgeous tags. Since they're made from paper, one option is to fall back on our favorite water-based markers for lettering, like the Tombow Dual Brush Pens and Tombow MONO Drawing Pens. In fact, we can even trade in our Faux Calligraphy for true Brush Lettering. For the sample project, I wanted to add some extra sparkle, so I used a brush-tip embossing pen and some gold embossing powder. This technique is easy to do, and it's sure to make your gift tags shine.

YOU'LL NEED

- Tag punch or paper cutter
- Cardstock
- Pencil and eraser
- Brush-tip embossing pen
- Gold (or other color) embossing powder
- Scrap paper
- Heat tool for embossing
- Washi tape (optional)
- Scissors
- Ribbon or twine

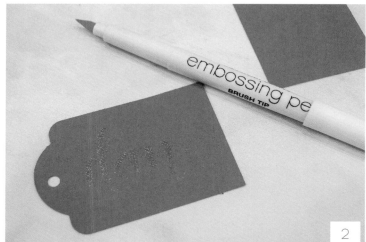

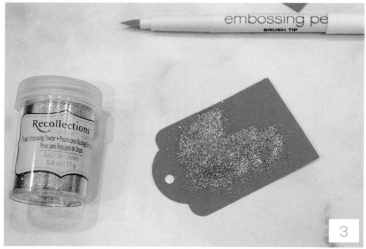

STEP 1: **Cut one or more tag shapes from cardstock.**

An easy way to do this is by using a tag punch. These are available in lots of shapes and sizes, so there's a perfect tag for every project. My punch even does double duty, cutting the shape then punching a hole in the top. If you don't have a tag punch, don't worry—there are other options for creating your shape. One is to use a paper cutter, and another is to use an electronic cutting machine like the Cricut or Silhouette, which will allow you to create everything from a simple rectangle to a very elaborate design. Finally, if you don't own any of these tools, you can simply trace a shape onto the cardstock and cut it with scissors.

STEP 2: **Sketch your design on the tag, then trace it with an embossing marker.**

Start by sketching with a pencil. Remember to press lightly, so that your marks can be easily erased. Also, if you choose to use the optional washi tape, don't forget that you'll be decorating the bottom section of the tag with it, so you'll want to leave that area blank.

Since we're using a brush-tip embossing pen, we can use our "real" Brush Script technique (page 148) when tracing the letters. If you prefer to use Faux Calligraphy (page 12) or another style of writing, you can use a bullet-tip embossing pen instead.

For my samples, I used a variety of words to show you some of the many possibilities you can create! I wrote "celebrate," "joy" and the names "Dan" and "Amy" in Brush Script.

STEP 3: **Sprinkle embossing powder over your lettering, making sure to cover it completely.**

I recommend putting a piece of scrap paper under the tag to catch excess powder. By using different colors and types of powder, you can change the look of the tags. Embossing powder is available in matte, glitter, gloss and just about every color you can imagine.

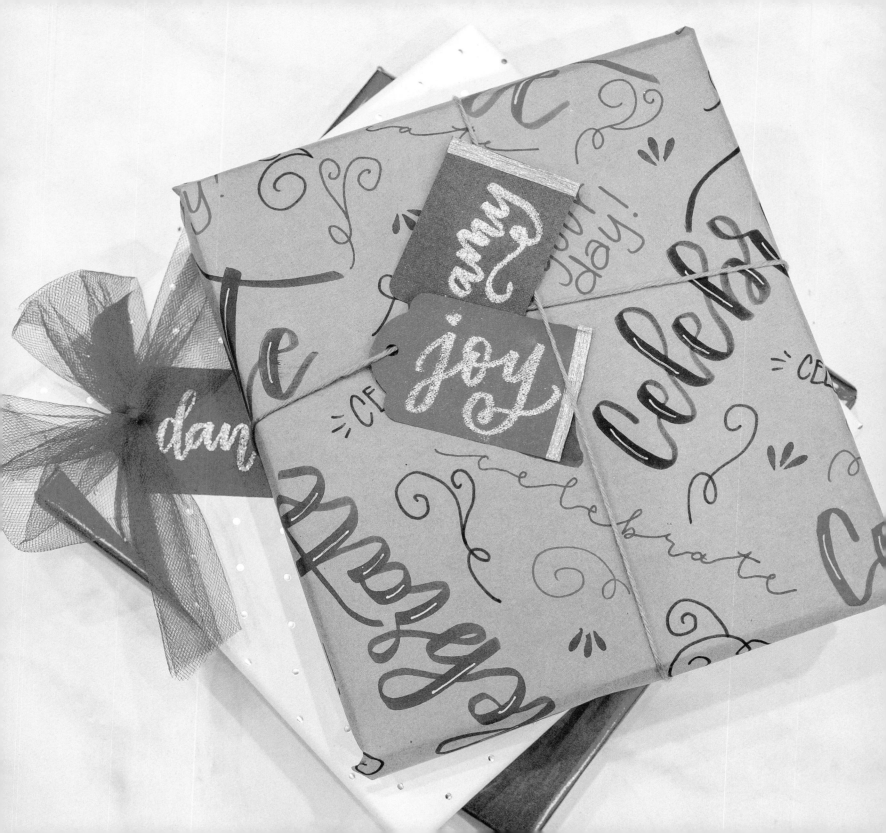

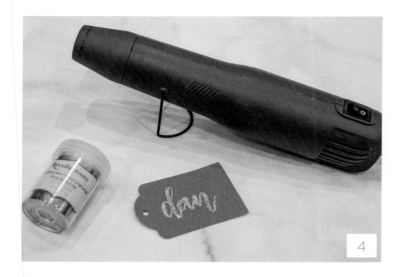

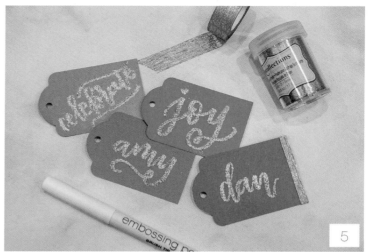

STEP 4: **Shake off the excess embossing powder, then heat your project using a heat tool.**

Pick up your tag and let all the powder that isn't stuck to your lettering fall onto the scrap paper. Then you can form a cone shape with your scrap paper and funnel the powder back into the container to use another time. To make the embossing magic happen, slowly move the heat tool around 2 to 3 inches (5 to 7.5 cm) above your lettering, allowing the heat to melt the powder into a smooth, shiny, raised finish. As soon as you see the powder change in appearance, move the tool to another area of the design to prevent it from burning or overheating. Follow the manufacturer's instructions for the heat tool to make sure you operate it safely.

STEP 5 (OPTIONAL): **Attach washi tape to the bottom edge of the tag.**

Different colors and patterns of tape will make the tag festive for all kinds of occasions.

STEP 6: **Using scissors, cut a piece of ribbon or twine and tie it onto the top of the tag.**

Or, if you prefer, just tape the tag to the gift and add a bow.

In addition to using different colors of embossing powder, you can change the look of your tags by choosing various colors of cardstock. No matter how you decide to personalize these tags, they're sure to be the perfect finishing touch on any package!

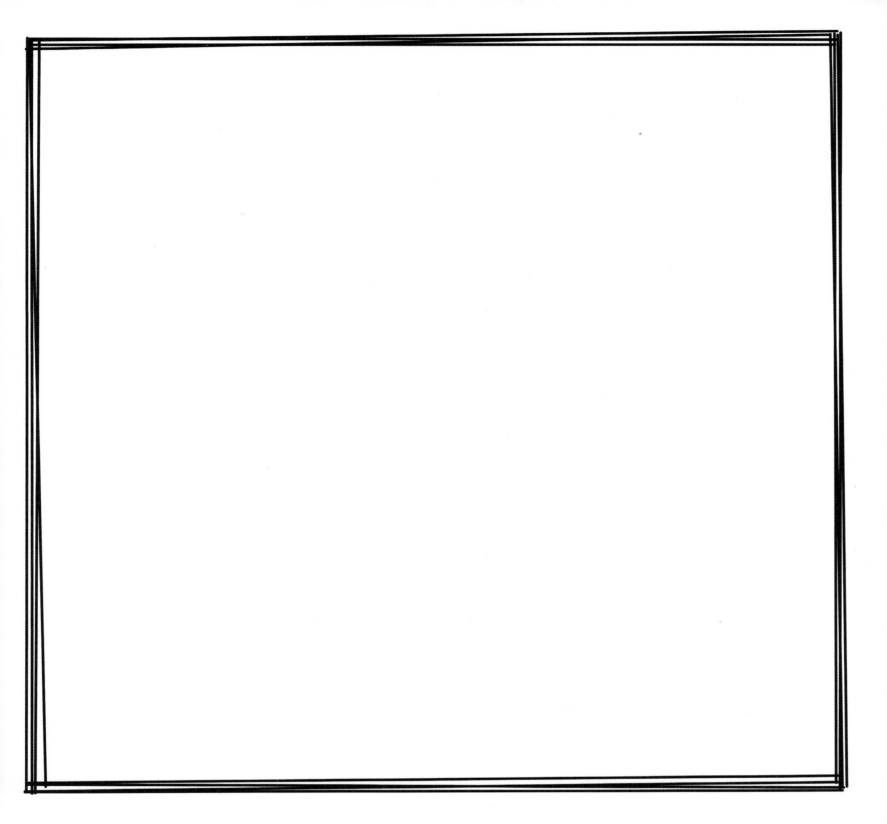

ALPHABET REFERENCE GUIDE

Throughout the projects in this book, I referenced the specific fonts and embellishments I used to letter the sample designs. Many of these can be explored in greater detail in my previous books, but I want to make sure that even if this is the first lettering book you ever pick up, you have everything you need to successfully complete each project. This chapter is meant to be a lettering reference you can use to master the various font styles used in these projects. The sample alphabets will help you see how to form each letter, then you'll be able to put the letters together to spell words and phrases in your designs. For additional practice, check out the downloadable practice pages on my website at amylattacreations.com/free-practice-pages.

abcdefg
hijklm
nopqrst
uvwxyz
0123456789

ABCDE
FGHIJ
KLMN
OPQRST
UVWXYZ

FAUX CALLIGRAPHY ALPHABET

This technique is the most common one used when lettering on surfaces other than paper, because it gives us the look of Brush Script but can be done with something other than a brush pen. In fact, you can use just about any writing utensil for this technique, including chalk, paint markers or even a ballpoint pen. The trick is to write your word in cursive, then find the downstrokes (places your pen was moving downward on the paper) and draw a second line next to the first. Color in the spaces between those lines to make those strokes look thicker, and voilà! Here's a guide to where the downstrokes are so you know which lines are thick and which are thin.

ABCDEFGHIJ
KLMNOPQRST
UVWXYZ
0123456789

CAPS–LOCK PRINT ALPHABET

This alphabet is very easy to create, because all you have to do is print capital letters with one small variation. Instead of crossing letters like "A" or "H" in the center, we're moving that x-height (see page 18) close to the top. Here's how doing that will affect each letter.

no bounce

bounce

BOUNCE LETTERING

Adding bounce to our lettering can serve two purposes. First, it adds visual interest, giving our words a free, whimsical feel. Second, it takes away the pressure of getting all of our letters in a perfectly straight line, which is especially helpful when we're writing on large or curved surfaces. The key to adding bounce is simply to let each letter drift a little above or below the one before it. Letters that end in downstrokes, like "n" or "h," are natural choices for the lower letters, while letters that end in upstrokes, like "a" or "e," look better sitting a little higher in the word. There's no perfect scientific formula for what letters go where—just let yourself play around and see what looks best. You'll get the hang of it in no time.

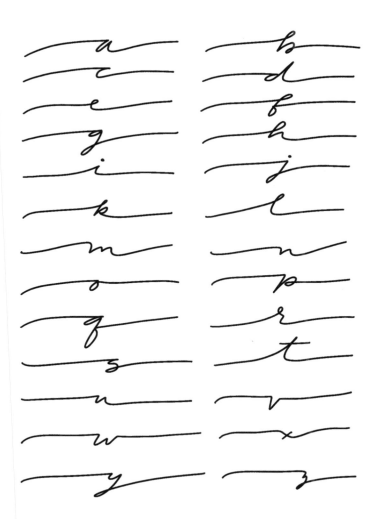

ABCDEFGHI
JKLMNOPQ
RSTUVWXYZ
abcdefghijk
lmnopqrstu
vwxyz
0123456789

ELONGATED SCRIPT ALPHABET

Imagine taking a word written in normal script, grabbing both ends and pulling horizontally. Think about how the letters would stretch and the extra space that would appear between them. That's what we're doing to create this alphabet. Here's a guide for how I write each letter, so you can practice putting them together.

FAUX CALLIGRAPHY PRINT

We all love the look of contrasting thick and thin lines within the letters of Brush Script and Faux Calligraphy, so it's no surprise that printed letters look great with contrast too. However, rather than thickening all the downstrokes, because of the way print letters work, they look best when we stick to making the leftmost part (or the stem, in the case of letters like "a," "d" or "g") of the letter thicker and leaving everything else thin.

abcdefg
hijklm
nopqrs
tuvwx
yz

ABCDEF
GHIJKL
MNOPQ
RSTUV
WXYZ
0123456789

BUBBLE LETTER ALPHABET

If you're anything like me, your middle-school notebook was probably filled with your own version of Bubble Letters. The ones I use in this book are large and full, with shadows on the lower-right side as if there were a light source in the upper-left corner. Here's how I draw them, but you can feel free to put your own spin on them if you have your own preferred style.

abcdefg
hijklm
nopqrs
tuvwxyz
0123456789

ABCDEF
GHIJKL
MNOPQ
RSTUVW
XYZ

STRAIGHT-LINE SCRIPT ALPHABET

This font is a variation on Brush Script and Faux Calligraphy, still featuring thick downstrokes and thin upstrokes. The difference is that we've removed almost all of the loops we typically use in our script writing and replaced them with straight lines. The result is a font with a totally different feel. Take a look.

$$o + l = a$$

Brush Script is a real art. It requires skill and practice as well as a special tool, the brush pen. When you apply pressure to the pen while moving it downward on the paper, you will get a dark, thick line. In contrast, when you release that pressure and move the pen upward, you should get a much lighter, thinner line.

The first drill I always recommend when someone is learning this technique is to make a series of downstrokes, followed by a series of upstrokes to get a feel for the difference in pressure. Then alternate them: down, up, down, up and so on. As you begin to understand how to do this, you can try things called overturns and underturns, where you go from a downstroke to an upstroke and vice versa without picking up your pen. Finally, you can attempt things like ovals and loops.

Don't be frustrated if this doesn't come naturally at first. It takes repetition and practice, but eventually the skill will become muscle memory and your hand will remember what to do.

abcdefg
hijklm
nopqrst
uvwxyz
0123456789

ABCDE
FGHIJ
KLMN
OPQRST
UVWXYZ

BRUSH SCRIPT ALPHABET

The Brush Script alphabet looks just like our Faux Calligraphy alphabet, except that it was created using the Brush Script technique and a brush pen instead of by drawing double lines and coloring them in. Everywhere there is a downstroke, you need to apply pressure to the pen, then release it to create the thinner lines in the rest of the letter. Don't worry if it takes you some time to get a feel for this technique. Practice makes progress!

abcdef
ghijkl
mnopq
rstuv
wxyz
0123456789

ABCDE
FGHIJ
KLMN
OPQRS
TUVW
XYZ

SIMPLE SCRIPT ALPHABET

When you're lettering a design, the more fonts you have to choose from, the better! Simple Script is a cursive font that doesn't have the contrasting thicknesses we find in Brush Script and Faux Calligraphy. When I use it, I tend to form my letters in the same way I would for Faux Calligraphy, but I don't go back and add any thickness to the downstrokes. I leave it as is: simple. Here's how I form the alphabet in this style.

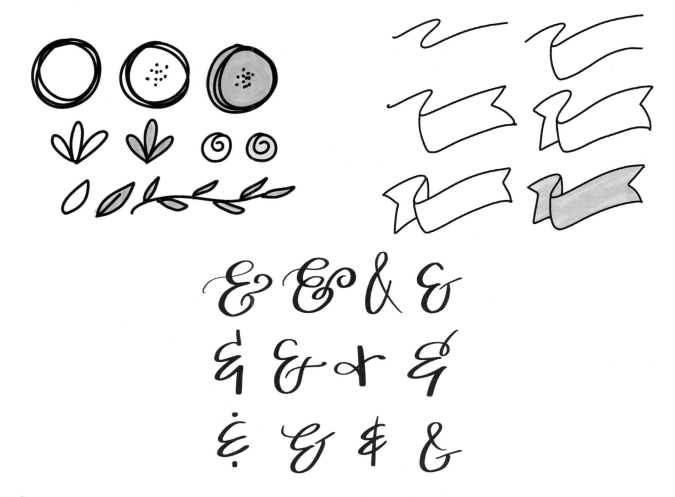

FLORALS

Florals are a great way to embellish just about any lettered design. My favorite type of flower is simply a few overlapping circles with some dots in the center and, of course, some color. A small spiral looks a lot like a tiny rosebud, and a few teardrop shapes grouped together make a cute little petaled flower. Vines and wreaths are easy to create, as they are just lines or circles with small leaf shapes extending from them. These little details can elevate the look of your lettering and add color to your art.

BANNERS

Banners are design elements that can hold some of your words, as you'll see in our Subway-Style Chalkboard Art (page 44) . Here is a step-by-step illustration of how to draw one. I recommend penciling your word inside a banner before tracing over it, just to make sure it fits!

AMPERSANDS

Sometimes it can be more fun and artistic to use a symbol rather than a word, like in the case of an ampersand for the word "and." Here are a variety of styles you can use for inspiration when drawing an ampersand.

DETAILED SUPPLY LIST

Although each project has a general supply list included, I also wanted to provide more detailed information about exactly what materials I used in case you want to duplicate one of the surfaces or use the same tools that I did. Here's a list of the specific things that went into each project and where you can locate them. Across the board, I used a Tombow MONO Drawing Pencil and Tombow MONO eraser, available at Amazon, JOANN Fabric and tombowusa.com. Things like scissors, a ruler, soft cloth and rubbing alcohol were the things I had around the house; any kind you have on hand will do.

SLATE SERVING TRAY (PAGE 11)
- Juvale mini slate cheese boards (6 pack): amazon.com
- Crayola® white chalk: Michaels, Target, Walmart
- Marvy® Uchida Bistro fine-tip chalk marker: amazon.com, Michaels

VINTAGE BOOK STACK (PAGE 16)
- Paperback books: Goodwill, your local thrift store or yard sales
- Tombow MONO Drawing Pen (size 03): amazon.com, JOANN Fabric, Michaels
- Twine: Hobby Lobby, Michaels, Walmart

INSPIRATIONAL MIRROR ART (PAGE 21)
- Mirror of any size and shape: Goodwill, thrift stores
- ZEYAR® Porcelain paint markers: amazon.com
- Sharpie® oil-based paint marker: Hobby Lobby, Michaels, Walmart

WOODEN WALL SIGN (PAGE 27)
- Whitewash Wood Wall Décor (large): Hobby Lobby
- Marvy® Uchida DecoColor™ acrylic paint pen (black): amazon.com, BLICK Art Materials, JOANN Fabric

FAMILY NAME FLORAL CANVAS (PAGE 31)
- Artist's Loft® level 1 back stapled canvas (9" x 12" [23 x 30 cm]): Michaels
- Pilot Juice Paint markers (black, green, metallic pink, metallic blue and gold): amazon.com, jetpens.com

STRIPES AND VINES FRONT DOOR SIGN (PAGE 36)
- Caydo 14" (35.5-cm) or 12" (30-cm) Wooden Circle Door Hanger (3 pack): amazon.com
- FolkArt® 1" (2.5-cm) Basecoat Brush: Michaels
- Painter's tape (1.88" [48 mm]): amazon.com, Target, Walmart
- FolkArt® Home Decor Chalk Paint (White Adirondack and Parisian Grey): JOANN Fabric, Michaels
- Pilot Juice Paint markers (black, white, gold and blue): amazon.com, jetpens.com

SUBWAY-STYLE CHALKBOARD ART (PAGE 41)
- ArtMinds™ Wood Framed Chalkboard (23" x 35" [58.4 x 88.9 cm]): Michaels; or a smooth wooden, metal or glass surface (any size and shape): Hobby Lobby, Michaels, Walmart
- FolkArt® Chalkboard Paint: amazon.com, Michaels
- FolkArt® Home Decor Wide Paintbrush: amazon.com, Michaels
- Crayola® white chalk: Michaels, Target, Walmart
- American Crafts™ erasable chalk marker (white): amazon.com, Hobby Lobby

FARMHOUSE-STYLE THROW PILLOW (PAGE 47)

- Threshold™ linen square throw pillow with removeable cover (white): Target; you can also purchase a pillow form and make or buy a separate pillow cover
- Cricut Explore Air™ 2: Hobby Lobby, JOANN Fabric, Michaels, Walmart
- Cricut® machine mat: Hobby Lobby, JOANN Fabric, Michaels, Walmart
- Cricut® iron-on vinyl (black): JOANN Fabric, Michaels, Walmart
- Cricut EasyPress™ 2 and mat: Hobby Lobby, JOANN Fabrics, Michaels, Walmart

CHALK-PAINTED FURNITURE UPCYCLE (PAGE 55)

- Wooden night table: Goodwill, thrift stores, yard sales
- FolkArt® Home Decor Chalk Paint: Hobby Lobby, JOANN Fabric, Michaels
- FolkArt® Home Decor Deluxe Small chalk brush: Hobby Lobby, JOANN Fabric, Michaels
- FolkArt® Home Decor clear wax: Hobby Lobby, JOANN Fabric, Michaels
- FolkArt® Home Decor wax brush: JOANN Fabric
- FolkArt® Home Decor Layering Block: amazon.com, JOANN Fabric
- FolkArt® Home Decor Layering Stencil (9.5" x 8.5" [24.1 x 21.5 cm]; Layer Flower): amazon.com, plaidonline.com
- Duck® Clean Release® 1.88" (48-mm) painter's tape or washi tape: Walmart
- FolkArt® Stencil Brush: amazon.com, plaidonline.com
- Pilot Juice Paint marker (white): amazon.com, jetpens.com

WATERCOLOR NECKLACE (PAGE 65)

- Bezel pendant tray with glass cabochon: amazon.com
- Fabriano® Studio Watercolor hot-press watercolor paper (9" x 12" [23 x 30 cm]): amazon.com
- Tombow Dual Brush Pens: amazon.com, Michaels, tombowusa.com
- Tombow MONO Drawing Pen (size 03): amazon.com, Michaels, tombowusa.com
- Pentel Arts® Aquash™ water brush: amazon.com, Michaels
- Mod Podge® Matte formula: Michaels, Walmart
- Necklace chain: Hobby Lobby, Michaels
- Wire cutters, pliers, jump rings, clasp (optional): Michaels

PERSONALIZED WALLET (PAGE 71)

- Small purse or pouch: Target's dollar section or the apparel section of your favorite retailer or department store
- Pilot Juice Paint markers (gold and silver): amazon.com, jetpens.com
- Aleene's® Spray Acrylic Sealer in matte finish (6 oz [180 ml]): amazon.com, Walmart
- FolkArt® 1" (2.5-cm) paintbrush: amazon.com, Hobby Lobby, Michaels, Walmart

FABRIC-PAINTED SHOES (PAGE 77)

- Women's canvas slip-ons (white): Old Navy
- Fabric Creations™ Soft Fabric Ink paint (black and white): amazon.com, Michaels
- FolkArt® detail paintbrushes: amazon.com, Hobby Lobby, JOANN Fabric, Michaels, Walmart

CUSTOM PHONE CASE (PAGE 83)

- BAISRKE white hard plastic and soft TPU phone case for iPhone X: amazon.com
- Cricut Explore Air™ 2: Hobby Lobby, JOANN Fabric, Michaels, Walmart
- Cricut® machine mat: Hobby Lobby, JOANN Fabric, Michaels, Walmart
- Oracal 651 vinyl: expressionsvinyl.com; or Cricut® Premium Vinyl™: Hobby Lobby, JOANN Fabric, Michaels, Walmart
- Cricut® StrongGrip Transfer Tape: Hobby Lobby, JOANN Fabric, Michaels, Walmart

GALAXY PRINT T-SHIRT (PAGE 91)

- Cricut Infusible Ink™ blank women's V-neck T-shirt: Michaels
- Cricut Explore Air™ 2: Hobby Lobby, JOANN Fabric, Michaels, Walmart
- Cricut® machine mat: Hobby Lobby, JOANN Fabric, Michaels, Walmart
- Cricut Infusible Ink™ Transfer Sheets: Hobby Lobby, JOANN Fabric, Michaels, Walmart
- Butcher paper (included with Cricut Infusible Ink Transfer Sheets)
- Cricut EasyPress™ 2 and mat: Hobby Lobby, JOANN Fabric, Michaels, Walmart

PAINTED TOTE BAG (PAGE 97)

- Axe Sickle canvas tote bag (any size; I used a 14½" x 14½" x 5" [36.8 x 36.8 x 13–cm] bag): amazon.com
- Duck® Clean Release® 1.88" (48-mm) painter's tape: Walmart
- Crayola® white chalk: Michaels, Target, Walmart
- Fabric Creations™ Soft Fabric Ink paint (Deep Teal, black, white, African Violet and Grey Mist): amazon.com, Michaels
- Assorted small paintbrushes (any brand): amazon.com, Hobby Lobby, Michaels, Walmart

EMBROIDERED DENIM JACKET (PAGE 103)

- Women's SONOMA Goods for Life® denim jacket (medium wash): Kohl's
- Crayola® white chalk: Michaels, Target, Walmart
- DMC® embroidery floss (964, Light Sea Green): Hobby Lobby, Michaels
- Embroidery needles: Hobby Lobby, JOANN Fabric, Michaels

GLITTERED BASEBALL CAP (PAGE 107)

- Black cotton baseball hat: JOANN Fabric
- Crayola® white chalk: Michaels, Target, Walmart
- Pilot Juice Paint markers (pink, white and gold): amazon.com, jetpens.com
- Fabric Creations™ Fantasy Glitter™ fabric paint (Meteor Shower, Supernova and Pixie Pink): Michaels, plaidonline.com
- FolkArt® detail paintbrushes: amazon.com, Hobby Lobby, JOANN Fabric, Michaels, Walmart

HAND LETTERED COFFEE MUG (PAGE 115)

- White mug: Goodwill (drinkware is also available at HomeGoods, Target, Walmart and other stores)
- ZEYAR® Porcelain paint markers (black, gold and silver): amazon.com

DECORATIVE FLOWERPOT (PAGE 119)

- Ashland® white small ceramic flowerpot: Michaels (similar items available at amazon.com, HomeGoods, Target, Walmart and other stores)
- Craft Smart® oil-based paint pens (extra-fine tip; black, gold and white): Michaels

ELEGANT MARBLE COASTERS (PAGE 125)

- Ceramic drink coasters with bamboo holder (white marble stone design): amazon.com
- ZEYAR® Porcelain paint marker (gold): amazon.com

EMBELLISHED HARDCOVER SKETCHBOOK (PAGE 129)

- Artist's Loft™ hardbound sketchbook (8½" x 11" [21.5 x 28–cm]; teal and gray): amazon.com, Michaels
- Sharpie® oil-based paint markers (black, gold and silver): Hobby Lobby, Michaels, Walmart

CUSTOMIZED CLIPBOARD (PAGE 135)

- Officemate® low-profile wood clipboard: amazon.com
- Pilot Juice Paint markers: amazon.com, jetpens.com

TEACHER CLASSROOM SIGNS (PAGE 140)

- Scalloped-edge chalkboards (any size): Walmart
- Pilot Juice Paint markers (assorted colors): amazon.com, jetpens.com

BRUSH SCRIPT MAP ART (PAGE 147)

- Map: printed from online sources
- Tombow Fudenosuke Soft Tip Brush Pen: amazon.com, Hobby Lobby, Michaels, tombowusa.com
- Photo frame (4" x 6" [10 x 15 cm]): HomeGoods, Target, Walmart

GOLD GLITTER GIFT TAGS (PAGE 151)

- Cricut® cardstock (12" x 12" [30 x 30 cm]): Michaels
- Fiskars® Standard Tag Maker: amazon.com
- Tombow MONO Drawing Pencil and MONO eraser: amazon.com, jetpens.com, tombowusa.com
- Moxy brush-tip embossing pen: papersource.com
- Recollections™ embossing powder (gold): Michaels
- Marvy® Uchida Embossing Heat Tool: amazon.com, Walmart
- Washi tape: Michaels, papersource.com
- Ribbon or twine: Hobby Lobby, JOANN Fabric, Michaels, Walmart

ACKNOWLEDGMENTS

Dan: Your encouragement and the way you believe in me means more than you will ever know. I love you more today than yesterday.

Nathan: Thank you for understanding when Mama had to work instead of play. I love you more.

Noah: When you write your cookbook, I promise to support you as much as you support me. Love you more forever.

Mom and Dad: You are such a big part of who I am today, and I am beyond grateful to have you as my parents. Thank you for raising me to believe I could be and do anything.

Erin Kerst: You brainstorm with me, give me honest feedback, make me laugh, encourage me, challenge me and are the sister of my heart. Thank you for all that you are to me personally and all that you do behind the scenes for Amy Latta Creations.

Jess Ridgely: I can never express how helpful your photo editing, photography and expertise were to this project. I couldn't have done it without you.

Christine Newkirk: The flowerpot was a stroke of genius. Thank you. And thanks to you and Bill for all the dog memes to keep me going.

The team at Page Street Publishing: Thank you for believing in me again. Cheers to five fabulous projects together!

Sarah Monroe: You're the best. Seriously. Thank you.

To you, reader: Thank you for picking up this book and the ones that came before it. Thank you for letting me share with you and teach you. It is an honor to share something I love so much with you. I hope you are inspired and feeling equipped to go forth and letter all the things!

ABOUT THE AUTHOR

Amy Latta is the bestselling author of *Hand Lettering for Relaxation*, *Hand Lettering for Laughter*, *Hand Lettering for Faith* and *Express Yourself: A Hand Lettering Workbook for Kids*. Her hand lettered designs have been featured by Gap and Starbucks, as well as other brands. Amy has her own monthly segment, "Getting Crafty," on the lifestyle show *Good Day PA*. She has also appeared on many news and lifestyle programs, including Hallmark Channel's *Home & Family* and *Midday Maryland*. She teaches lettering workshops both locally and nationally and is passionate about helping others discover their own creativity. Amy and her family live in Hampstead, Maryland. Learn more at amylattacreations.com.

INDEX

T

V

W